D0773456

Drawing and Painting
Horses

Dedication

Although they are not horses,
I dedicate this book to Madadh
and Kgosi, two of the wolves of
Wolf Watch UK.

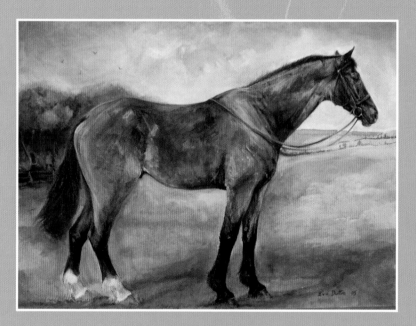

Drawing and Painting
Horses

Eva Dutton

Search Press

First published in Great Britain 2012

Search Press Limited
Wellwood, North Farm Road,
Tunbridge Wells, Kent TN2 3DR

Illustrations and text copyright ©
Eva Dutton 2012

Photographs by Paul Bricknell at
Search Press Studios

Photographs and design copyright
© Search Press Ltd. 2012

ISBN: 978-1-84448-543-7

The Publishers and author can
accept no responsibility for any
consequences arising from the
information, advice or instructions
given in this publication.

Suppliers
If you have difficulty in obtaining
any of the materials and
equipment mentioned in this book,
then please visit the Search Press
website for details of suppliers:
www.searchpress.com

Printed in Malaysia

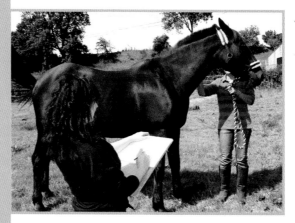

Acknowledgements

With thanks to
Tony Haighway, Doodle
and Lucky for the
displacement activities
they provided, and to all
the horses used as
models for this book.

Front cover
My Dream Horse
59 x 40cm (23¼ x 15¾in)
*A shape drawing, tonal drawing and the final
painting done in watercolour. This is the horse I
would love to own.*

Page 1
Zen
22 x 26cm (8⅝ x 10¼in)
*A watercolour painting in the making, done from
my memory of a horse I worked very closely
with a long time ago. He always seemed to be in
high spirits.*

Page 2
Blue Roan
36 x 26cm (14⅛ x 10¼in)
*This horse's name was Jack; he liked to take
a crafty bite at the unsuspecting, so I kept my
distance when doing this painting! This was
completed in watercolour and mixed media
and the background was Jack's field near Much
Wenlock in Shropshire.*

Page 3
Locket
25 x 22cm (9¾ x 8⅝in)
*Pencil with a light watercolour wash. This is
based on a Morgan Mare I knew years ago.*

Opposite
Dappled Cob
28 x 22cm (11 x 8⅝in)
*A pencil drawing using an eraser to create
dapples by smudging. Blue was a feisty riding
school pony.*

Contents

Introduction

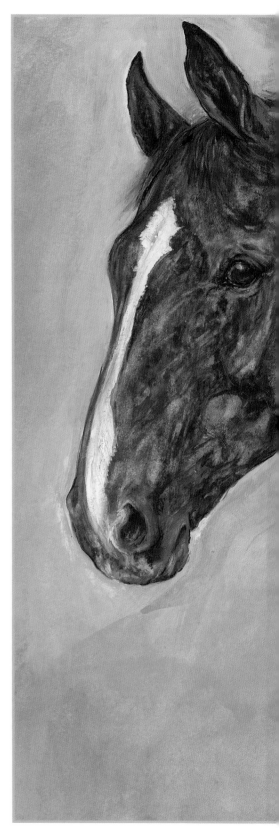

What is it that makes one want to paint and draw horses? The answer will be different for everyone, but there is no doubt that they are an extremely powerful, challenging, beautiful and often poignant subject for an artist to depict. This book has evolved in such a way as to take the reader on a journey, beginning with the initial spark that inspires one to capture something of a horse's spirit through the media of drawing and painting. Help and advice are offered, and ideas suggested, giving a starting point, direction and structure that guide you through various stages to the development of a completed painting.

Sections are included on materials and equipment that won't break the bank, basic anatomy, proportion and movement. Methods and techniques that are practical, are discussed in a way that enables both the beginner and more advanced student to gain confidence and learn along the way. Illustrations throughout provide information, reference and food for thought; there are suggested exercises and finally there are five step-by-step projects for you to have a go at.

While working directly from life is heartily encouraged, the use of photographs and other reference material is also discussed. At the end of each section are the names of artists whom I feel are relevant and of benefit to look at.

Use this book as a helpful guide to get you going and to inspire you, but remember, nothing is set in stone. Feel free to experiment, alter and question what you learn. Make your own work as individual as the horses you paint!

Working Study of Two Companions
36 x 26cm (14¹⁄₈ x 10¼in)
This shows Katmandu and friend done in watercolour mixed media. Katmandu can also be seen in the Head and Neck demonstration on page 76.

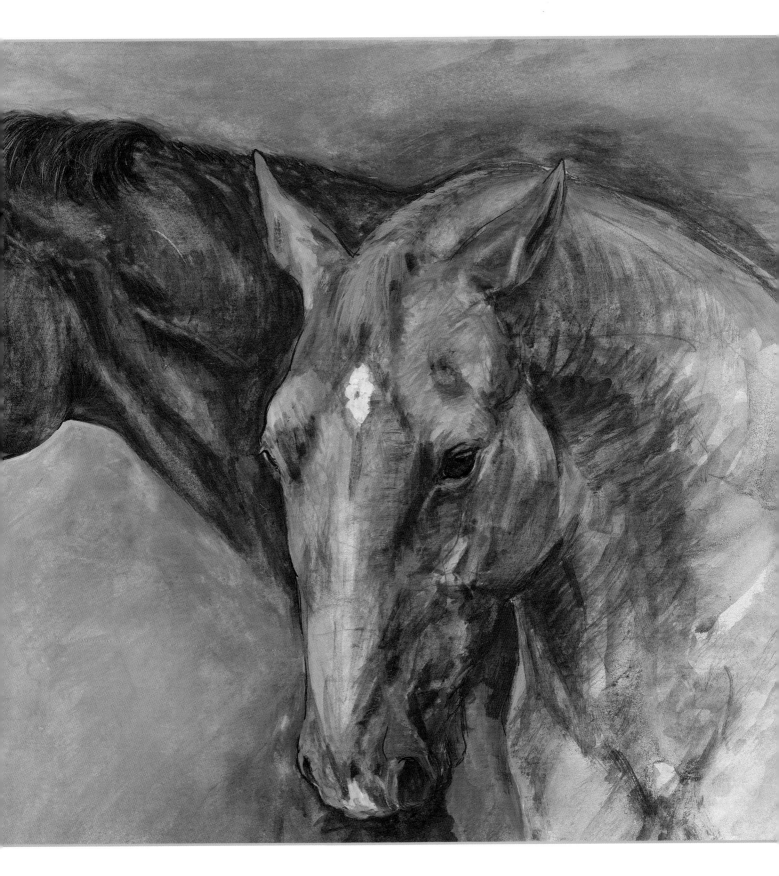

Materials

One of the joys of creating art is all the lovely materials that go with it, but it can also be confusing and expensive. To begin with, try to keep things to a minimum. With practice you will begin to discover what works best for you. Visit your nearest art supplier and have a look around. You are bound to see materials that you will enjoy using. Ask if you may try out pens, pencils, pastels, etc.; a good shop will help as much as possible to make sure you are happy with your purchases. Also, most known brands supply leaflets about their products; these can be very useful in helping you decide if something is for you.

Never forget that producing paintings and drawings is as much about the media you use as the subject matter you portray, so enjoy, explore and experiment with your chosen equipment.

Paper

There are many different types of paper available to the artist, and these can be obtained as single sheets or in sketchbook format that are glued or spiral-bound. I prefer the latter for field studies as you can easily double back the cover to give you a firm surface to use as a drawing board. These pads come in lots of different sizes, surface textures and weights. For general sketching and drawing, cartridge paper is a good choice. I favour a heavyweight satin surface which is very smooth. If you enjoy doing very detailed work, Bristol board, which is designed for airbrush work, takes pen and pencil extremely well, giving a lovely clean-cut feel to the drawings.

Some papers have a slight textured surface and will hold media such as charcoal well, or you could even use pastel paper, which gives a greater textural quality designed to hold pastels, chalks and charcoals. It also comes in different colours to give you a ready-made ground.

For the very rough sketching out of ideas, perhaps for compositions, lining paper is a good choice. It is relatively cheap and comes in big rolls so you can feel freer to experiment without worrying about wasting lots of expensive paper. However, whenever possible, try to use good quality paper, as this can have a marked effect on how you draw.

Cartridge paper, Hot Pressed watercolour paper and pastel paper.

When you begin to use colour washes, perhaps buy a watercolour pad designed to take the application of wet paint to the surface. They come in different paper weights, ranging from around 190gsm (90lb) up to 640gsm (300lb). The lighter ones need stretching to prevent buckling, although you can buy some blocks with the edges stuck down so that you can work directly on them, which is useful for collecting field studies.

There are generally three surface types of watercolour paper: Rough, which has a textured, dimply surface to hold colour and create texture; Not, which has slightly less texture but still absorbs colour well; Hot pressed, a smooth surface good for fine details and illustrative work. All three, depending on their weight, allow you to be quite brutal and adventurous when working on them – just because they are watercolour paper does not mean that this is all you can use on them. I use just about everything.

This is where you really need to experiment and discover drawing for yourself. If you buy loose single sheets of paper and cut them to size, don't throw the offcuts away – instead colour them with a wash, let them dry and have a stack clipped together so that you can choose a suitable one when drawing. Having a coloured ground can get rid of all that scary white and give a fresh richness and depth to the sketch or drawing.

Drawing boards

A range of different sizes is useful, including a lightweight one for ease of carrying when working in the field. Any firm surface will do, but be careful of warping especially on a board on which you want to stretch watercolour paper.

Using a board larger than your paper allows you to clip it closer to the top of the board, making it easier to control your pens, brushes etc and giving you more freedom in your arm and hand movements. This is really useful if you are sketching in the field and for example sitting down on the ground, propping your board against your knees.

If you are using loose sheets of paper, pad your board with several layers of cheap paper to give a cushion and a better 'feel' when drawing. This is not so necessary when using brushes, as you will not be pressing so much.

A well-used drawing board.

Sketching materials

Always carry a tiny sketchbook, one that easily slips into a pocket, bag or glove compartment, and a pen or pencil. You never know when the muse will strike. Also carry a spare pen in case it runs out mid-scribble, and use elastic bands to prevent sketchbook pages from flapping.

In addition to this, have a very simple basic kit and, if possible, carry this with you or keep it somewhere accessible at home to jot down the memory of your observation on your return, or develop it slightly from your tiny sketchbook scribble. Correction fluid in pen form doubles as an eraser and highlighter.

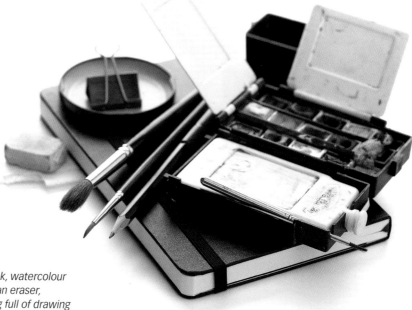

Small sketchbooks, fineliner pens, rollerball gel pens and a correction fluid pen.

A comprehensive kit is necessary for more in-depth studies and for times you know you are going out with the purpose of sketching. The photograph shows a range of items. Try to experiment as much as possible and find what you feel most comfortable with. Stick to student quality paints for this purpose until you are sure, before committing to the expense of artists' quality.

A comprehensive sketching kit comprising a sketchbook, watercolour painting set, brushes, an F pencil and pencil extender, an eraser, kitchen paper, bulldog clip, jar lid for water and belt bag full of drawing implements.

Drawing materials

You should enjoy using your drawing materials, so experiment with lots of different types to find the ones you get the most satisfaction from using. Find ways of exploring line, tone, mood, atmosphere, shapes, emotions and colour all through the use of your drawing equipment. If you do not get on particularly well, for example with crayons, do not give up – leave them for a while, use something you feel more confident with then come back and try them again. Practice really does make perfect. Sometimes you even find that different subject matter will dictate to you which materials to use.

Shown below are a range of drawing materials that I use all the time.

Pencils come in different grades, varying from the harder H grades through to softer, more smudgable B grades. A 3H gives a fine, hard line, whereas a 3B will give a softer, darker line. I often use an F grade, which is in between the two.

I use both sharpeners and a craft knife to sharpen pencils. You can get a very fine point using a knife as long as the blade is sharp.

Pens such as ballpoints, technical pens and gel pens can give a lovely, flowing line which offers ease of control, but you often need the tips to point down for the ink to flow, so they are not always suitable for work at an easel. Brush pens can be used as a fine point or in a broad sweep – great for creating quick impressions. Felt tips are similar, are a lot easier to control and come in a vast range of colours.

Pen and ink is good for quick mark making but is a bit fiddly if drawing in the field as it is easy to knock the ink over. You can also use a brush with the ink and there are some beautiful translucent colours, great for studio work.

Charcoal is charred wood. You can buy the stick form like a fine twig, or chunkier sticks. It also comes in a pencil format in different grades and this allows greater control. With charcoal it is a good idea to use a specially designed fixative. This is lightly sprayed over your completed work to prevent smudging.

An eraser, as well as eliminating mistakes, is also a tool in itself. Try softening edges or blurring detail by using different pressures to create the varying effects.

Wax crayons designed for children to use are cheap to buy and give an intense colour. You can get some interesting effects using them on textured papers. They are great for quickly blocking in large areas of colour.

Pastels have some similar uses to crayons, but are softer and easier to smudge into each other to create a vast range of colours and tonal qualities. The best ones are expensive and break easily so treat them with care. I find a small range of browns and creams will create lots of different horse coat colours.

Finally my favourites, a brush and a tube of white gouache. You can use this quick-drying opaque paint dilute as a wash or more thickly applied to create a textured layer that you can draw over when it is dry. White gouache is great for field studies. You can apply highlights or soften details by washing over them. Gouache comes in a wide range of colours, similar to watercolours. Beware of mixing it with watercolour to create what is called body colour, as it can look chalky.

Clockwise from top: fixative spray, craft knife, artist's pens, felt tip pens, soft pencils, a scalpel, charcoal, wax crayons, an ink pen, brushes, ballpoint pens, a brush pen, an eraser, white gouache, soft pastels in a range of browns and creams and acrylic ink.

Painting materials

Whatever painting materials you choose, try and have a practice and a play with the medium beforehand, to give a little understanding of its qualities and capabilities.

Watercolour is quite transparent and is used diluted with water. It comes in a huge range of colours. Burnt sienna is very useful for painting horses. Watercolour comes in tubes or pans and as student's or artist's quality. The latter is more expensive but worth investing in once you become more confident. Small boxes containing pans are useful for field studies as they are easily portable and often contain mini water carriers as well as brushes. Watercolour is almost a stain of colour which is built up in layers. It dries quickly and various media can then be added to alter its effect. Once dry, it becomes soluble again with the addition of water, so to a small degree it can be reworked. Exposure to strong sunlight can cause watercolour and indeed all paintings to fade.

I sometimes use conté pencils and sticks alongside watercolours. They are good for noting colour observations so are especially useful when working quickly from life.

Gouache is an opaque medium, which can also be mixed with water to dilute it. It is used in a similar way to watercolour but can be used more thickly. If used too thickly, however, its surface will crack when it dries. It is cheaper than watercolour and comes in pots or tubes to prevent it drying out.

Acrylics are quick drying paints that can be diluted with water or other specialist mediums and once dry, the paint is insoluble. It is good if you want to paint in thick layers and covers large areas quickly. Colours mix well and a huge range is available. It can look a bit plastic-like when dry, so practise lots to begin with.

You can buy specialist brushes for each paint type, ranging from very expensive pure sable through to cheaper synthetic ones. Brush sizes are usually indicated from 0 upwards but this can vary from brand to brand and country to country. Brush handles vary in length, so find what you feel comfortable with. Brush heads come in different shapes – I find round brushes are a good basic shape and I go for a range of head size from very small (usually about size 2) for adding details, up to a size 10 for doing washes and broad areas. Look after your brushes well and do not do what I did when a student at college, using my Dad's best watercolour brushes for oil painting and then forgetting to clean them!

Sponges dipped into paint and dabbed on to paper can be used to cover large areas. Try using them wet and dry to create different textures.

Kitchen paper is indispensable for blotting and removing paint. Try crumpling a sheet up and lightly dabbing it into wet paint to create clouds, horses' coats and other texture effects.

I use gummed tape for stretching paper or taping it down on a board. It requires water to make it stick, but be careful as once it has dried, you cannot completely remove it.

Use old jam jars and mugs for water containers, and for field studies a small container with a secure lid is a must.

Soft pastels in stick or pencil form are also useful as you can draw over the top of painted areas and intensify colours. A putty eraser can create good textures on these areas.

Clockwise from top: kitchen paper, acrylic paints, a sponge, gummed tape, watercolour tubes and pans, gouache tubes, synthetic brushes, a putty eraser, soft pastels, brushes, conté pencils and sticks, a box of watercolour pans and a water container.

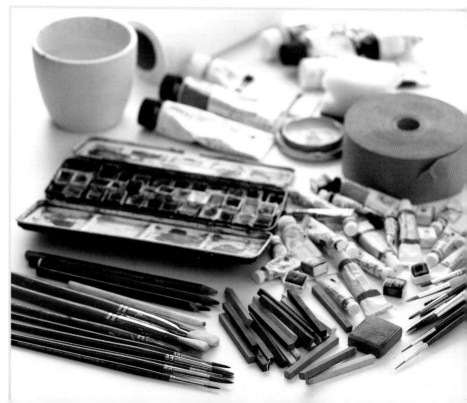

Other materials

These are a few bits and pieces I sometimes use when producing paintings.

A magnifying glass I use this if I have to work from a photograph and also to focus and isolate areas in a painting I am struggling with. It sometimes helps to enlarge an area to understand what is going wrong.

Wire and pipe cleaners are useful to create quick models of horses. This is explained more on page 38. **Masking tape** can be used to tape the wires together.

Air drying clay or other modelling clays are useful to create quick horse shapes, as explained on page 39. You will need a **small board** on which to place these. A small selection of **modelling tools** will help when using your clay but you can easily use old nails or cutlery instead to model with.

Modelling wax is lovely for doing finer detail especially on a smaller scale.

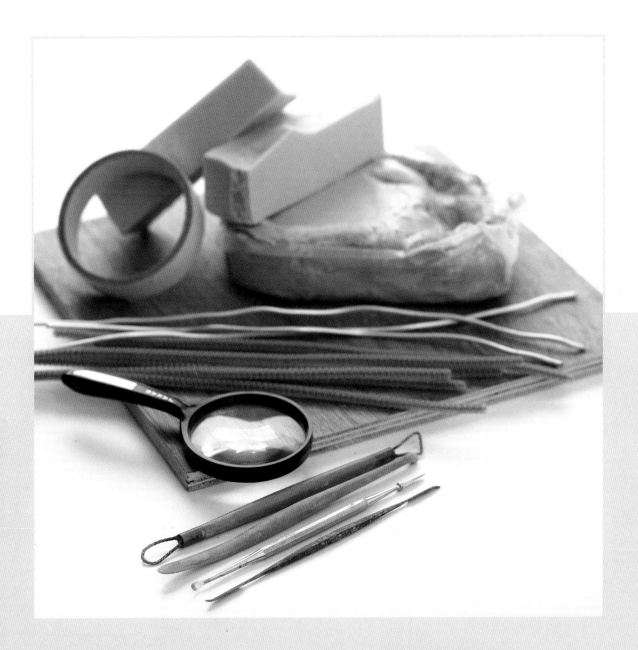

How to use this book

Using this book will give you lots of ideas, information, an understanding of the shape and structure of a horse, and hopefully a feel for something of its spirit.
Here is an example of how to proceed.

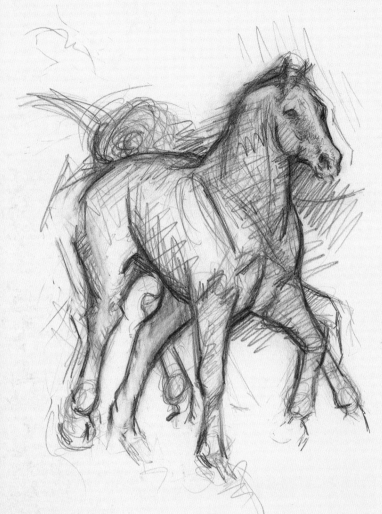

Start with a quick, scribbly sketch, done whenever possible from life. Then this can be developed further, either on the spot or back in the studio. See the Starting to draw section on pages 26–39 for more on scribble drawings.

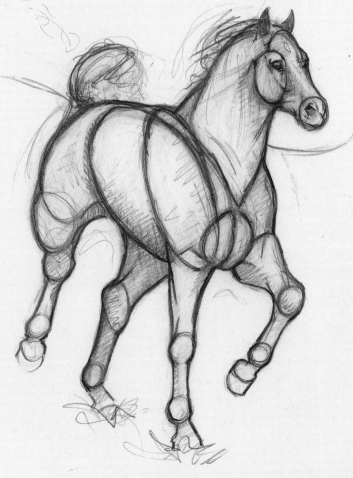

Next, use simple shapes to help understand the form of the horse, and overlay these with a fluid line to keep a sense of movement and life. See pages 29–31 for information on shape drawings.

This is the same drawing but taken a stage further. Add tonal shading and more details such as highlights in the eye, face and leg markings and some background features. You may want to leave this as a finished drawing or proceed to the next stage. See the Developing drawings section on pages 40–59.

This is the final painting I did from the previous drawings. Of course there are several painting stages prior to this. If you look at the demonstrations towards the end of the book it will help you understand the process from start to finish. Also see the Painting horses section on pages 60–73.

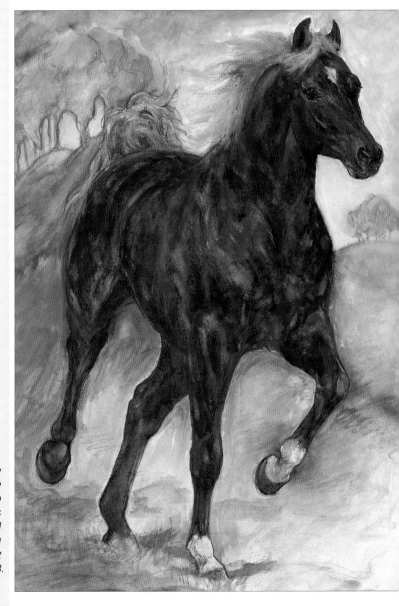

Finding inspiration

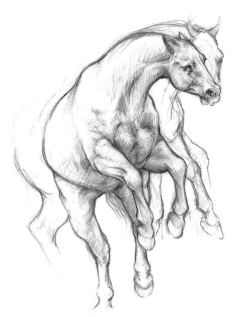

Imagine this scenario – it's a sultry summer day with the distant low rumble of thunder. You are out walking in the countryside and while you are passing a field of grazing horses, there is a sudden flash and bang right overhead which causes them to spook. One horse, in particular, a chestnut, catches your eye as he shies and then plunges forwards, light flickering across his coat. How you would love to capture the energy and elegance of this animal. So, very quickly, you scribble your ideas down on to a scrap of paper and before the rain begins, you rush home where, over a cup of coffee, you begin to plan a painting of Storm Horse. Now the hard work, fun and sense of achievement begin.

Horses galore

These two pages show aspects of horses' movements done in various media and showing different approaches. There are pencil, pen and crayon sketches highlighting action and movement, shape drawings exploring proportions, anatomical drawings to gain a deeper understanding of structure and paintings to explore emotions and feelings.

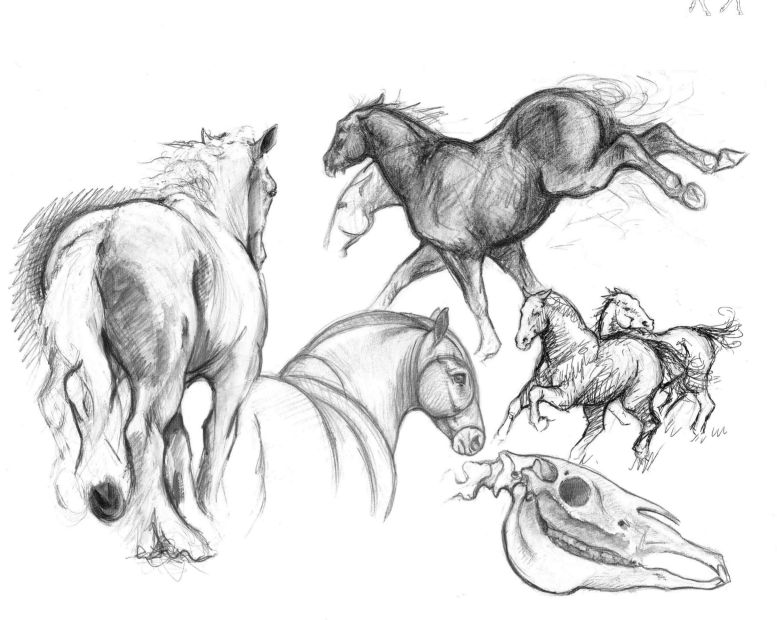

The spark of an idea

The spark that gets the creative juices flowing is extremely elusive and can come from numerous sources, so grab it quickly. Getting any thoughts and observations down on paper, however roughly, will stop that spark from simply burning to a cinder and being forgotten. Do not worry if you then do not look at these jottings for some time, as you will find that even a simple scribble will cause that spark to flare again and the excitement of your original inspiration will return.

As your work progresses from sketch to completed painting, keep reminding yourself what it is that makes you want to do this. What are you identifying with that you would like to capture? Reminding yourself of this question will help retain a spontaneity through all the stages of producing a painting, which is invaluable, as this spontaneity can sometimes be lost.

So, you are armed with your scribble drawing of Storm Horse (it could be worth a fortune in years to come), but what comes next? Well, ideally you need to carry on drawing from life, but as this is not always practical or possible, we will also look at other ways of developing ideas.

Drawing from life

The question I am most frequently asked as a painter of horses is, 'How do you make them keep still?' The answer is, you don't! What you learn to do is observe, look, watch, sketch and draw as much as possible. Surprisingly soon you develop the eye-brain-hand coordination that allows you to pick up on the line, shape and form that builds into a recognisable horse.

Although drawing from live horses will teach you the most, it is also the most difficult when you are first starting, so by all means use other reference material to help you get going: photographs, film footage, sculpture, paintings, and indeed, this book, will all help you develop an understanding of your subject so that when faced with a real horse, you will have gained some confidence in your abilities as an artist.

Later on, we will look at some ways of recording observations when working directly from life, but for now here (top right) are some ideas for places to go to do this. By the way, don't be put off by people looking over your shoulder; be pleased they are interested enough to have a look and remember it is very easy to criticise, and very brave to actually have a go at drawing in public.

Good places to draw horses

- The parade paddock at a racecourse.

- Horse shows, especially in hand classes where horses will be standing for lengths of time without a rider.

- Riding schools often have viewing galleries and they are sometimes indoors, which is great for bad weather sketching.

- Horse sales – but don't come home with one!

- Workshops, for example with the Society of Equestrian Artists, where you can meet like-minded people.

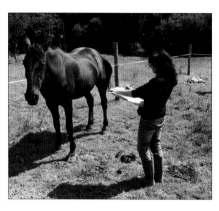

Here I am sketching Clover, who is twenty years old. It was a hot day and she was very sleepy!

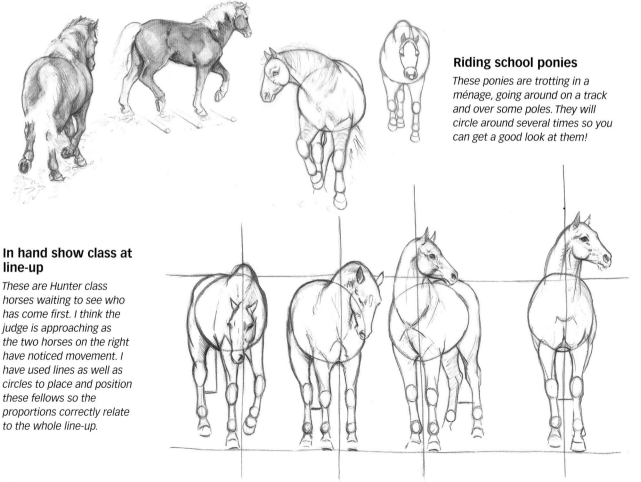

Riding school ponies

These ponies are trotting in a ménage, going around on a track and over some poles. They will circle around several times so you can get a good look at them!

In hand show class at line-up

These are Hunter class horses waiting to see who has come first. I think the judge is approaching as the two horses on the right have noticed movement. I have used lines as well as circles to place and position these fellows so the proportions correctly relate to the whole line-up.

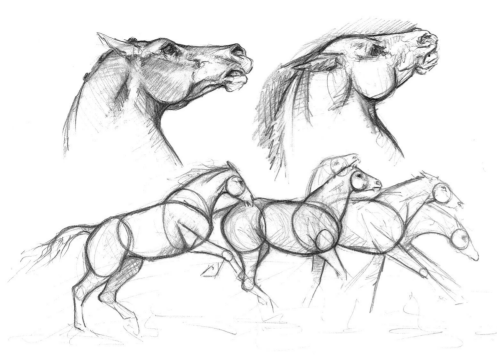

Racehorses

These racehorses were closely bunched together. To begin with, I quickly drew circles to position the horses, adding details later on. I tried to follow an arc shape to add to the balance of the group.

• Always obtain permission to have contact with other people's horses and never go on to private land without it.

• Do not be tempted to feed titbits to horses – it can cause a lot of problems.

• Be careful not to drop anything when sketching – horses will find it and eat it!

• Flapping sheets of paper and the hiss of spray fixative can scare horses.

• Never leave a tied-up horse unattended.

• Set yourself up in an appropriate place to sketch so as not to interfere with horses, riders or even mares with their foals, however cute.

A family group

I see this family group on the way to the riding school I instruct at. They are very closely bonded and I wanted to show them in close proximity to each other. Looking clockwise from top left, you can see that they begin as a scribble drawing, develop into a shape drawing, then a tonal detail drawing, and finally a painting.

As a final thought on drawing from life, if possible, and obviously with permission, collect some horse hair from the coat, mane and tail, as this will really help you to understand texture and colour.

If you are really keen, it is possible to get bones and even hooves from dead horses. Ask your local vet or hunt kennels – these are completely orthodox sources. Please don't do as George Stubbs, the famous horse painter, did, and employ body snatchers. I do, however, recommend that you look at his anatomical drawings!

Using reference material

There is a lot of information out there, so be choosy and try to pick out quality images.

Remember that while photographs can be extremely useful, they are no substitute for drawing from life. Use them when needed to aid memory and learn about the look of something, but you still need to be aware of expressing thoughts and feelings in your work that are unique to you. This will not happen by slavishly copying a photograph. Also, often what works brilliantly as a photograph simply will not work as a painting.

Digital cameras with their ability to take mini films are very useful especially if you can understand the instruction manual!

Keeping a folder of useful images is a good idea, even better if you are organised enough to put them in sections such as heads, eyes, rearing, jumping and so on. You can easily keep adding to your collection.

My folder packed with reference material taken from various sources such as magazines, books and photographs.

Choosing reference photographs

Here the hindquarters are missing and the forelimbs look odd as they are too close together.

This photograph is too close up and distorted to be of use as reference material.

These three photographs, above and right, show reasonable detail against a good colour background. They also show a pose typical of this horse.

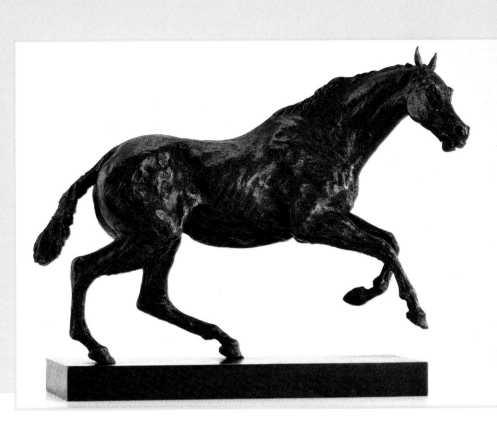

Storm Horse

This is my sculpture cast in bronze measuring approximately 38 x 27cm (15 x 10⅝in). He is a thoroughbred Morgan and was modelled from life and sketches. I now use the sculpture as reference to draw from, as the sketches below show. Sketching from sculptures gives you the advantage of being able to get a three-dimensional feel to your work, as you can move about the object but it stays still! Most cities have an equestrian sculpture somewhere, which can give you excellent practice at drawing from 'life'.

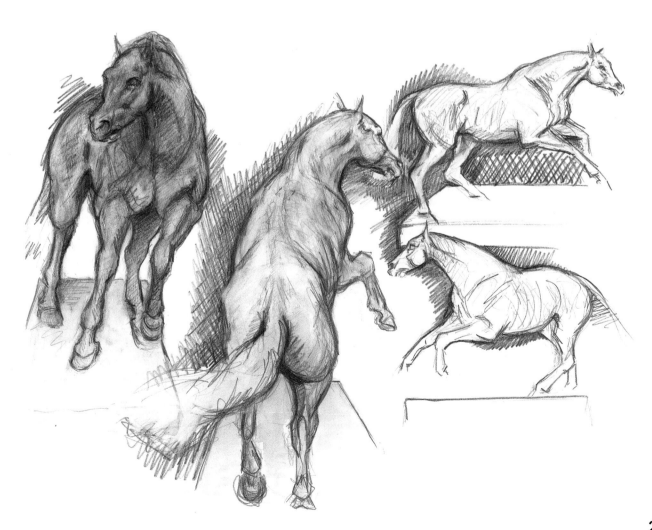

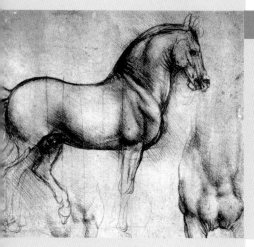

Artists to look at

- Henry Moore – Look for his sketched ideas for sculptures, such as those in the book *Animals* by W. J. Strachan.

- Leonardo Da Vinci – There are Da Vinci sketchbooks containing drawings of horses (see left).

- Lucy Kemp-Welch did paintings mainly of heavy horses, as well as the illustrations to *Black Beauty*, the 1877 novel by Anna Sewell.

- Captain Adrian Jones was a sculptor and painter who specialised in animals, especially horses. Look for his equestrian sculptures.

Looking at the work of other artists will inspire and instruct you in your own horse drawings. Below are pages from my sketchbook done as a demonstration on how horses move.

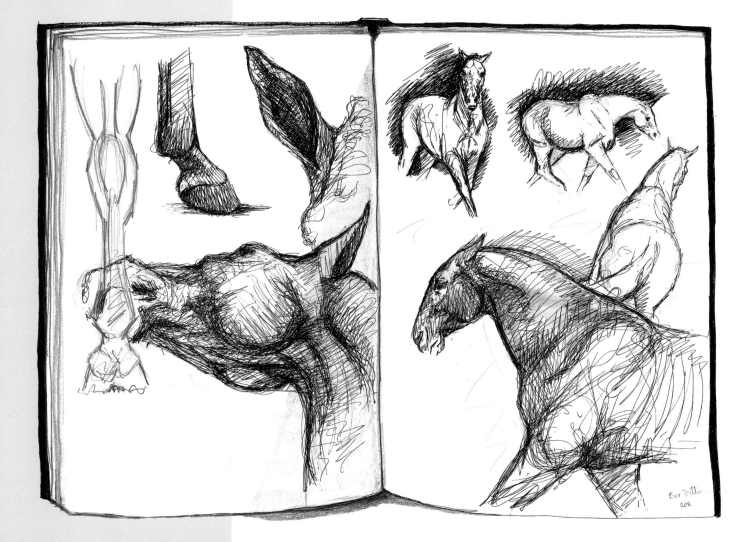

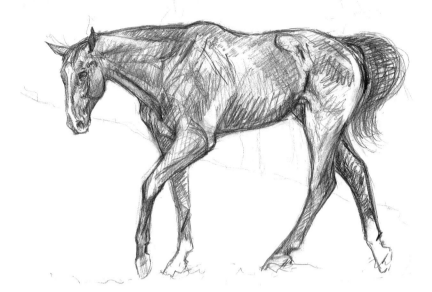

Suggested exercises

- Have a look at as many sources as you can.

- Sketch directly from life if possible and keep asking yourself what is interesting you in the scene.

- Your local art gallery may have some equestrian works – ask as they may be stored away.

My sketch of this horse, Katmandu, walking, was done from life.

The sketches below were done at the British Museum and they show part of a frieze originally in the Parthenon in Athens.

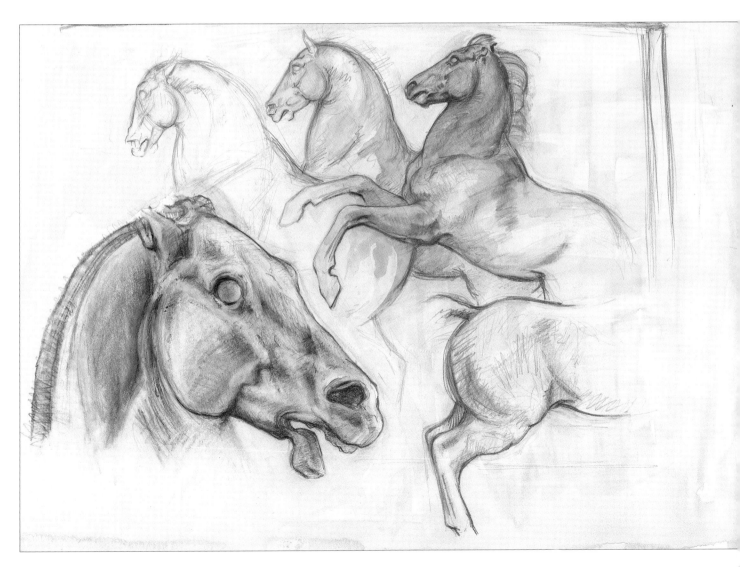

Using anatomical drawings

Before we delve any deeper, it is worth learning a little basic anatomy. This will help almost literally to put flesh on to your scribble and shape drawings. Look closely at the illustrations on these pages, and if possible, go and look at real horses or good photographs to grasp a sense of what is going on just below the surface.

Take time to look at a static and then a dynamic, moving horse. Notice how muscle shape alters, especially on the neck, shoulders and hindquarters.

It is also helpful to note the difference between human and equine anatomy. We have evolved to stand upright while horses have evolved to stand on all fours, in effect standing on tip-toes to enable them to outrun predators.

When drawing and painting, try to put your body into the horse's posture, feel the tensions, relaxations, contractions and expansion of muscle, tendons and ligaments. This will help develop an empathy towards horses' moods and feelings and give more sincerity to your work.

Points of a horse

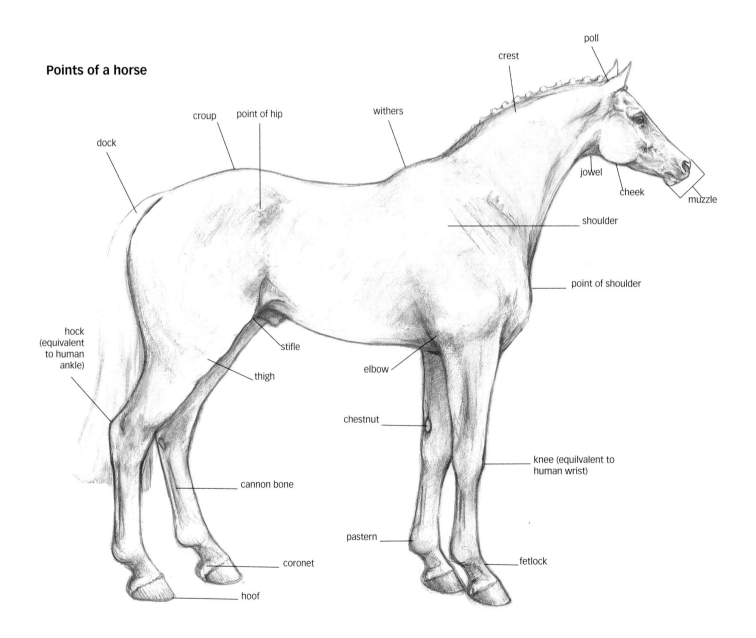

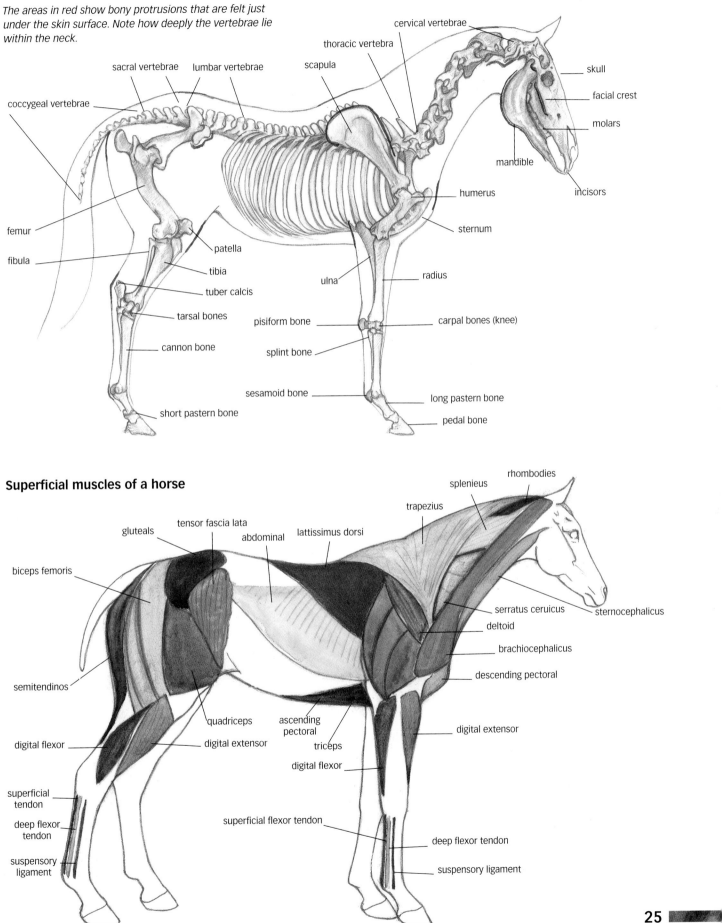

Skeleton of a horse

The areas in red show bony protrusions that are felt just under the skin surface. Note how deeply the vertebrae lie within the neck.

cervical vertebrae

thoracic vertebra

sacral vertebrae

lumbar vertebrae

scapula

skull

facial crest

molars

coccygeal vertebrae

mandible

incisors

femur

humerus

fibula

sternum

patella

tibia

radius

tuber calcis

ulna

tarsal bones

pisiform bone

carpal bones (knee)

cannon bone

splint bone

sesamoid bone

long pastern bone

short pastern bone

pedal bone

Superficial muscles of a horse

rhombodies

splenieus

trapezius

gluteals

tensor fascia lata

abdominal

lattissimus dorsi

biceps femoris

serratus ceruicus

sternocephalicus

deltoid

brachiocephalicus

descending pectoral

semitendinos

digital flexor

digital extensor

quadriceps

ascending pectoral

digital extensor

triceps

digital flexor

superficial tendon

deep flexor tendon

superficial flexor tendon

deep flexor tendon

suspensory ligament

suspensory ligament

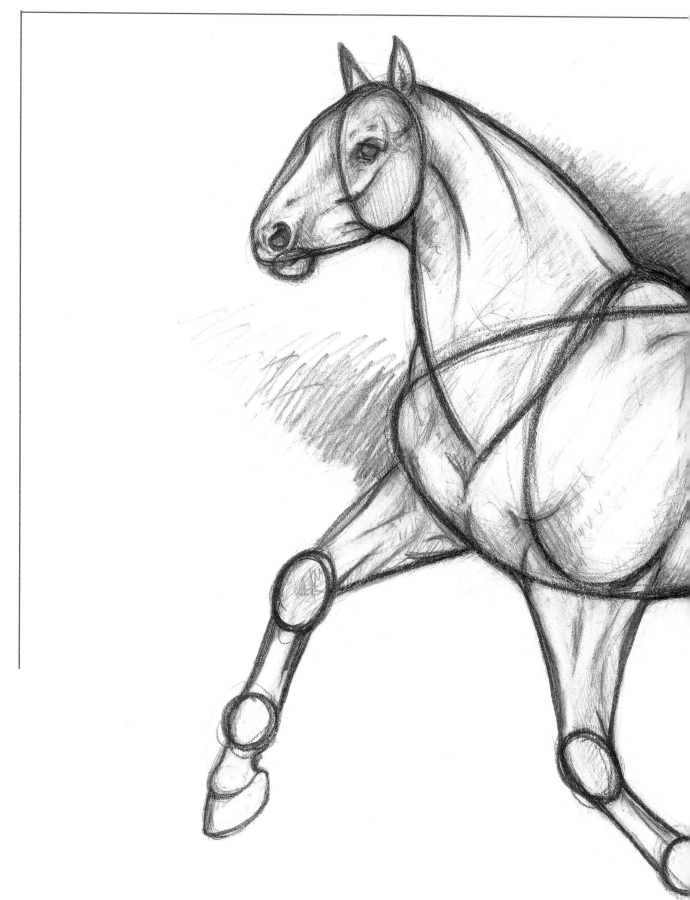

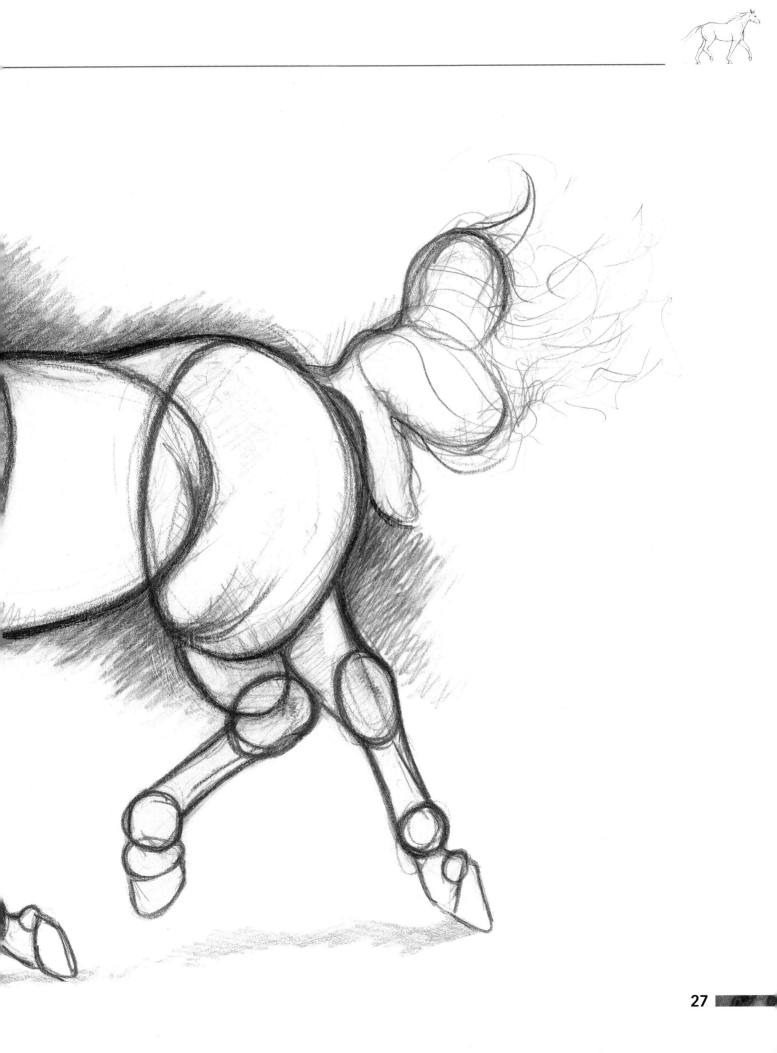

Scribbles and shapes

At the moment, we are mainly concerned with sketches; quick, simple first impressions. Later, we develop these into drawings and these tend to be more in depth, carrying more information, detail, tone, scale and volume as well as a host of other considerations. But for now we need a way to record our observations and ideas so that we have them for future reference and can utilise them to explore, develop, discard and ultimately to produce finished drawings and paintings.

There is also no reason why your sketches cannot be your ultimate aim. If you feel you have no desire to further them, enjoy them as they are. In fact, you may find it is the act of producing them that is your motivation and not an end painting.

Scribbles

Don't worry at this stage if you are unsure of how best to use your chosen materials. The technical skill is secondary at the moment to your enthusiasm and interest, so just scribble away. Some of my scribble drawings are shown below.

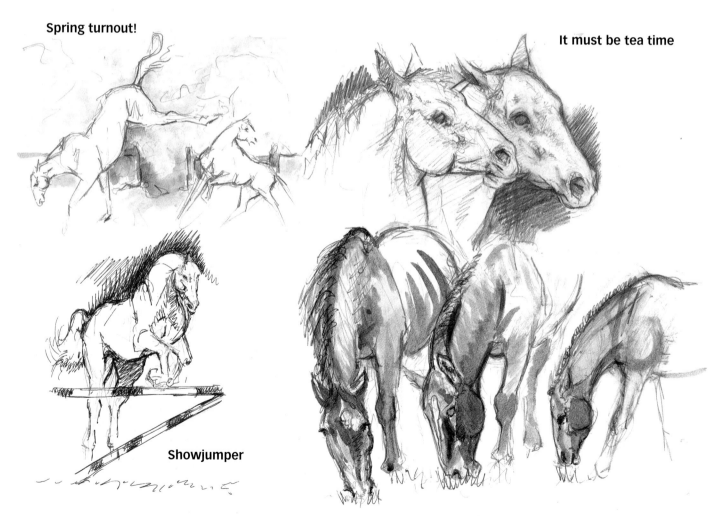

Spring turnout!

It must be tea time

Showjumper

Grazing family

Shape drawings

Along with your scribbles, you may find that using some simple shapes will help guide you to gain more accuracy. These shape drawings are also quick to jot down. You may find it useful to refer to my last book, *How to Draw Horses in Simple Steps*. Initially, sketching this way may cause you to lose some of the lovely looseness of scribbles, but as long as you remain aware of this, you can then go on to develop a more flowing and dynamic line over the top of these shapes, as I have done in some of the drawings shown below. The shapes will simply aid the structure, acting as a frame on which to build. More shape drawings are shown overleaf.

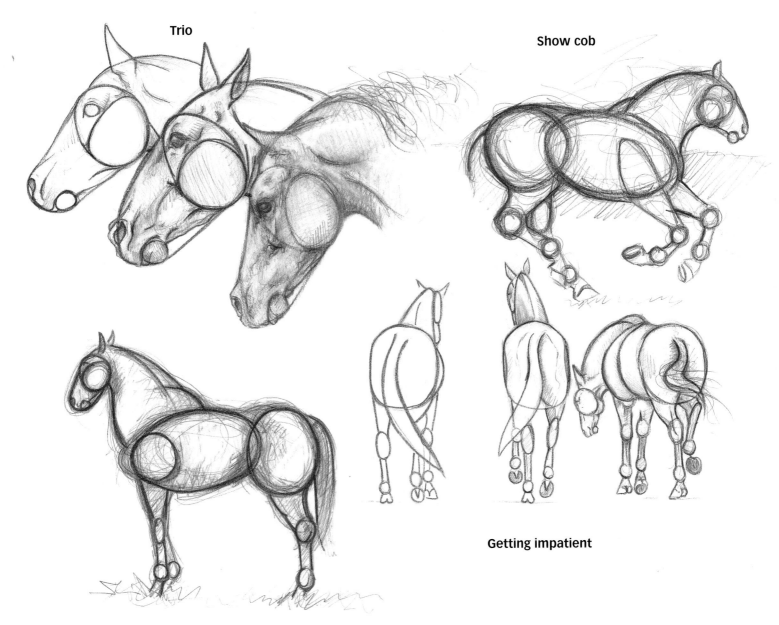

Trio

Show cob

Getting impatient

Show hunter

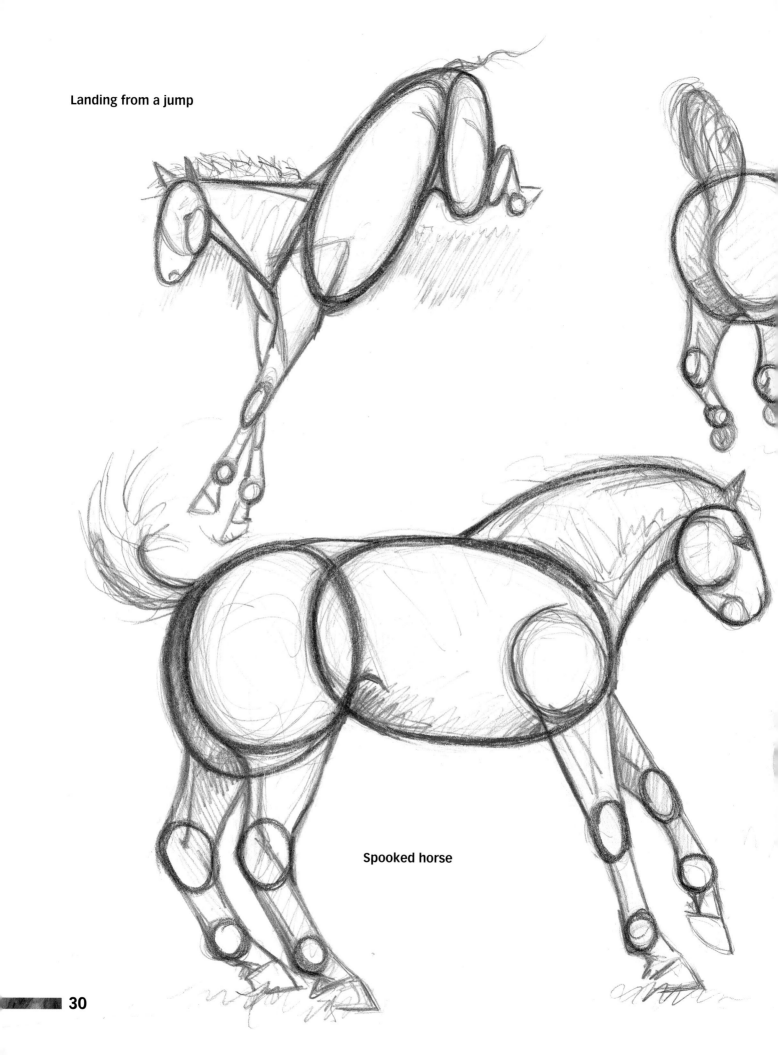

Landing from a jump

Spooked horse

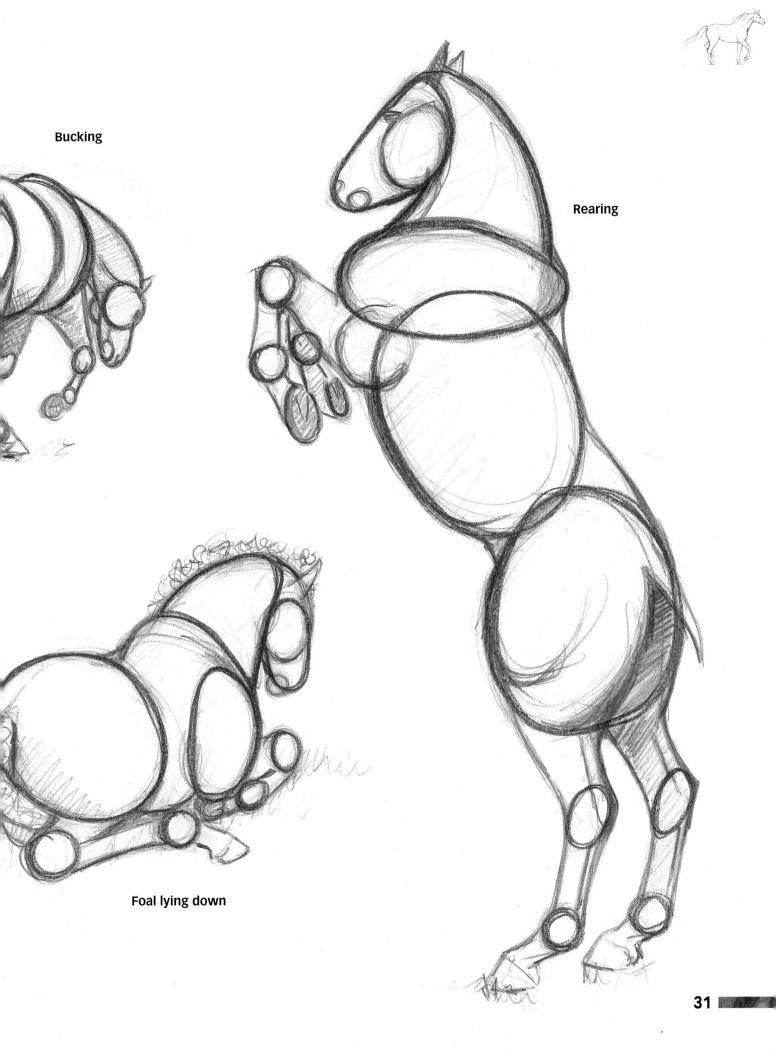

Bucking

Rearing

Foal lying down

Shape and scribble drawings

The are shape drawings with scribble over the top to show the fluidity and motion of the subjects. They show different views of racehorses from the trackside with a race in full flow.

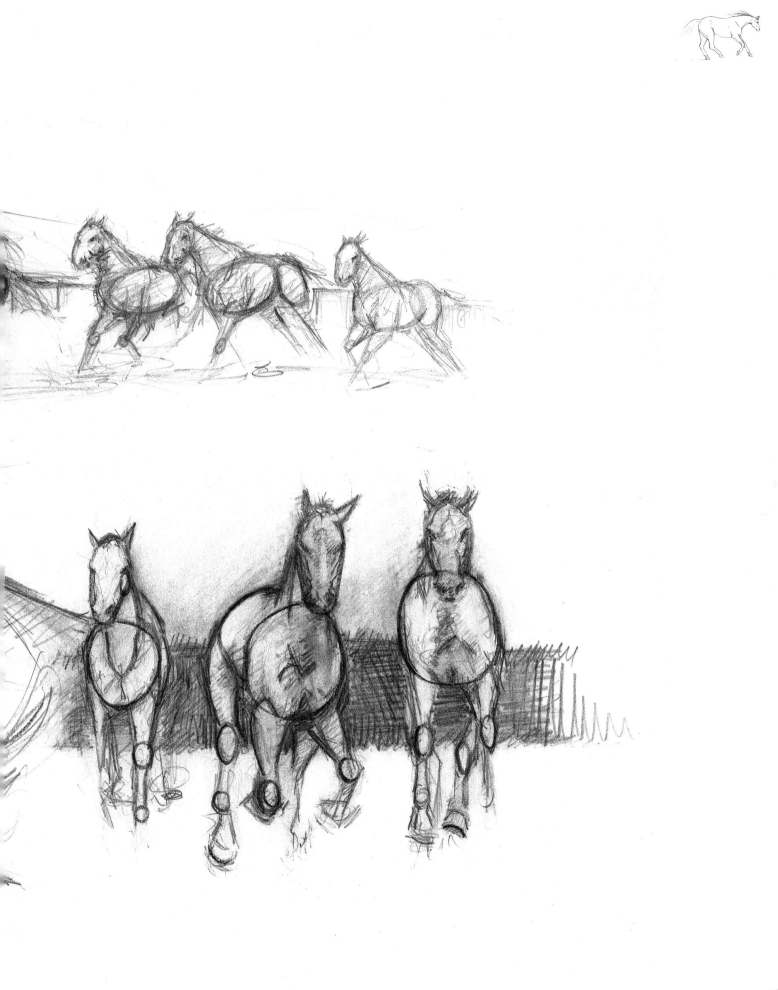

Recording observations and ideas

So here we go with some different ways of recording experiences and observations that I have found helpful in my career as an artist.

I think the best advice I can give is to sketch every day – even if you only have a five minute slot, you will begin to improve. Draw anything and everything; do not worry if it's not always a horse, you will still be building up drawing skills. Family pets make very good subjects.

Although you do not want to get bogged down by details early on in your sketches, elements such as eyes and nostrils can be useful as 'anchor points', helping you to relate positioning and distances. Do not worry about the actual detail of these anchor points in themselves. Instead, try to look at an overall outline to develop a sense of positive attitude, emotion and where appropriate, movement. The illustrations opposite show some very easily recognisable outlines of horses.

Try blotting out detail by half-closing your eyes (this also helps later on when distinguishing between tonal qualities).

If looking at several horses, perhaps in a herd, try to see them almost in a block form, like a sculptor carving out of air (see the outlined herd on page 36). You may find reading Ted Hughes' poem 'Horses' helpful here for the image he conjures up.

Look at the air space around the animal – this helps you to grasp shape and form. For instance a trotting horse shows triangles between each forelimb and hind limb when viewed from the side (see page 36).

You don't need to be drawing a horse to improve your observation and drawing skills – it can be really useful to draw your family pet. These sketches show my spaniel, Lucky, and deerhound, Doodle.

When drawing from life, have a go at observing the animal without so much as glancing at your paper as you sketch, especially when faced with a scene you know will not last long. Imprint in your mind as much as possible the horse's image and not your hand trying to draw him. You will also find this encourages you to become freer in your hand movements so this may be a good time to start using a larger sketchbook or paper on a board.

Draw from memory, so watch your subject for as long as possible, and once he has galloped off into the far, blue distance, close your eyes immediately. This seems to help you retain an image in your mind's eye, almost like a piece of film footage.

Use copious written notes alongside your sketches (see page 37). These are very useful for noting colours, which you may want to use in your completed works. This is also quicker than using paints, which helps when you are out in the field in case your subject rapidly disappears, for example on the racetrack where you only get fleeting moments to record the colours of silks.

These horse outlines show the need to gain a sense of the subject's attitude, emotion and movement, rather than getting bogged down in detail. They show, clockwise from top left: relaxed, startled, inquisitive, attacking and aggressive attitudes.

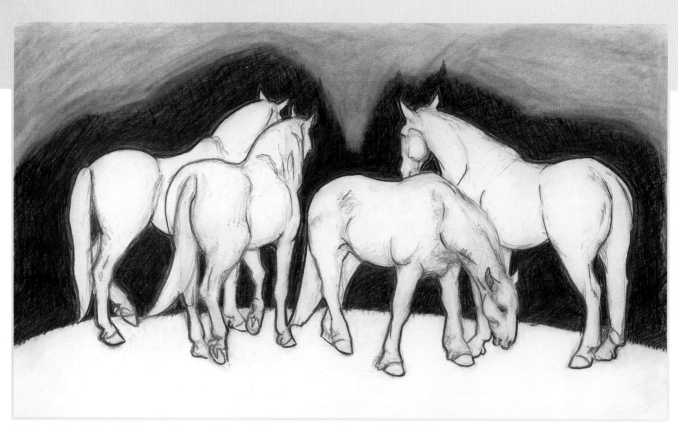

In this outline of a herd of horses, I have added a red line to create an almost solid block of the grouped animals. This is helpful when drawing several animals together.

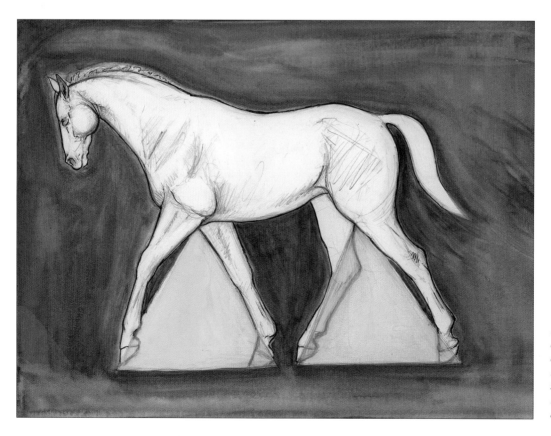

Look at the air space around the horse you are drawing. This trotting horse viewed from the side shows triangles between the forelimbs and the hind limbs.

Sketches with notes

Sketches with the notes I scribbled on them at the time. The one on the right became Storm Horse, the sculpture shown on page 21.

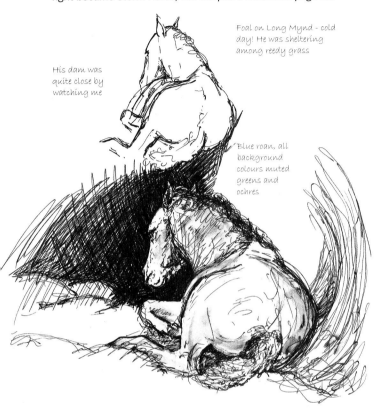

His dam was quite close by watching me

Foal on Long Mynd - cold day! He was sheltering among reedy grass

Blue roan, all background colours muted greens and ochres

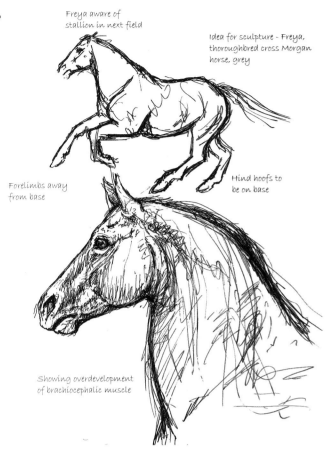

Freya aware of stallion in next field

Idea for sculpture - Freya, thoroughbred cross Morgan horse, grey

Forelimbs away from base

Hind hoofs to be on base

Showing overdevelopment of brachiocephalic muscle

Move further back

Final painting to show hilly background

Move to see more of forelimbs

Strong shadows need to be added. Use terra verte & Payne's gray

This compositional sketch shows three views of the same horse, Katmandu, with the notes I made when planning for the finished painting.

Pipe cleaner horses

I find these little models of horses help me when trying to achieve a sense of movement and of the animal's posture without worrying about details. They are a great help in composing a picture where several horses are involved. Have a little herd handy to help you when sketching movement and compositions. Pipe cleaners or thin wire can quickly be bent into all sorts of stick horse shapes and kept intact by pushing their legs into florist's oasis or polystyrene. Here is how to assemble them:

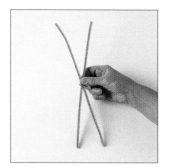

1 Use three pipe cleaners of equal length. Take two and hold them crossed over in the centre.

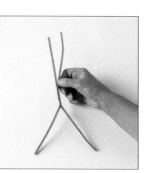

2 Twist them together as tightly as you can for about 6cm (2³/₈in) to make the horse's body and legs.

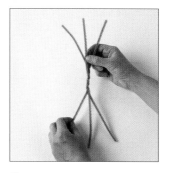

3 Take a third pipe cleaner and twist it three times round the twisted part of the body. This makes the head, neck and tail of the horse.

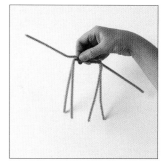

4 Bend the legs down into position.

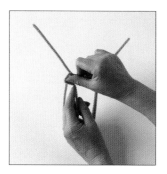

5 Shape the front legs by bending the shoulders 1cm (³/₈in) backwards, using your thumbnail. Then bend the other way.

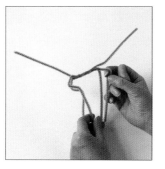

6 Bend the hind legs but in the opposite direction to the front legs, making the stifle joints first by bending forwards.

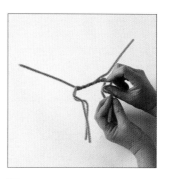

7 Make the hock joints by bending backwards lower down.

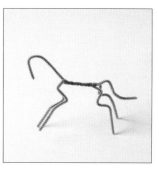

8 Splay the legs slightly so that the horse stands securely, and shape the head and tail.

9 You can place the horse in florist's oasis or polystyrene and pose it rearing, kicking, bucking, or in whatever position you like.

Clay horses

Try making quick little models in clay or modelling clay. You might end up with something not particularly horse-like, but it really gives you a feel in your hands for the contours, hollows and solidity of the animal, which helps when you come to paint.

Suggested exercises

- Do some doodles from memory and imagination. This helps to highlight the aspects of drawing horses that interest you.

- Use both scribble and shape drawings and try as many different views and positions of horses as possible, to see which best suits your way of sketching. Have a go at developing your own technique.

- Throw nothing away, and every few weeks, scan through your sketches as you may be surprised how that 'useless' scribble could hold some valuable information to help you complete a painting!

Artists to look at

- Marino Marini

- Charles Tunicliffe

- Henry Moore's Sheep Sketchbook

- Edgar Degas' racehorses

I considered the sketch below a 'useless scribble' when I first did it, but I did not throw it away, and later developed it into the Shires Under Blossom painting on the right.

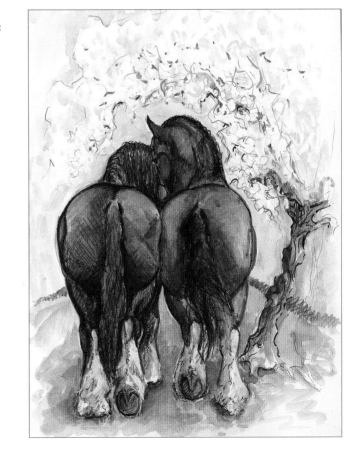

DEVELOPING DRAWINGS

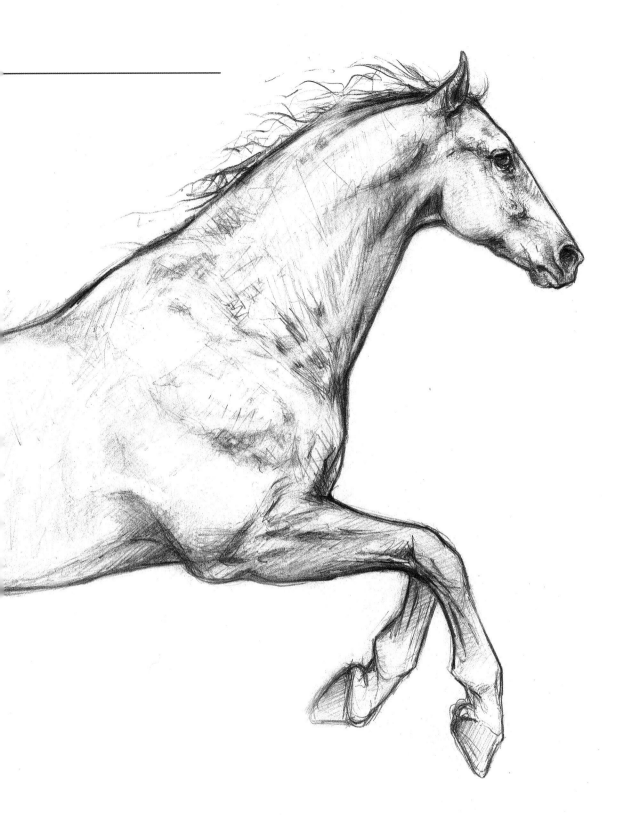

By now we should have sketchbooks crammed with scribble and shape drawings, and it would be great to begin developing these ideas into drawings that can be used as preparatory works for finished pieces. Let us have a look at some techniques to use our materials to best effect, and some of the issues we need to consider when developing our drawings further.

Techniques

Heavy Horse

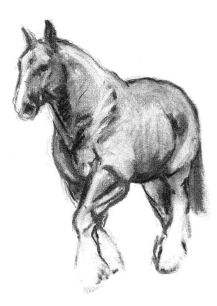

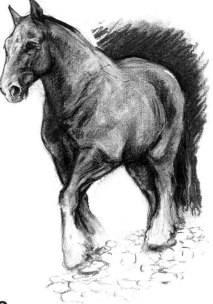

1 Using charcoal stick on paper, an outline has been boldly drawn in. Some basic detail was added using the stick almost like a pencil – see the contours of the shoulder blade and the muscle of the raised forelimb. The eyes and nostrils have been blocked in and the long hairs ('feathering') on the lower legs have been left as white paper. I then used my finger to smudge the charcoal into the body, head, neck and upper legs, darkening it to suggest a roundness under the belly and the underside of the neck. I used a smudge of charcoal to add his tail.

2 I picked out further detail using a charcoal pencil to give greater control on the neck muscles, forelimbs and face, smudging areas which I wished to darken such as the inside of a hind leg and the hip area. I used stick charcoal to add a suggestion of background to emphasise the powerful hindquarters. A hint of cobbled ground was added using the pencil charcoal lightly. Finally a smidgeon of white gouache was added to highlight feathering on his legs and suggest movement in his tail to distinguish it from the background.

High Stepping Hackney

1 I used a 2H pencil to do a quick outline of this delicate looking horse. To emphasise the lightness of her trot, I deliberately omitted her hooves and tail outline. I lightly drew in some facial details.

2 I used an F grade pencil to draw a bolder line over the outline. To emphasise the arch of the neck and high tail carriage, I added pencil strokes to the background. This helped to give definition under her jowl and neck while retaining the delicacy of her posture. I allowed the tail to float into the white of the paper by using a few light F pencil strokes. Minimal tonal shading was used to suggest the contours and volume of her limbs, tummy and chest.

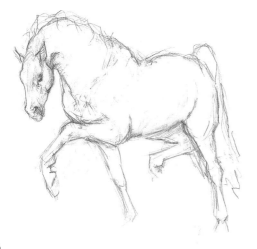

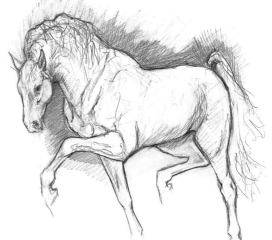

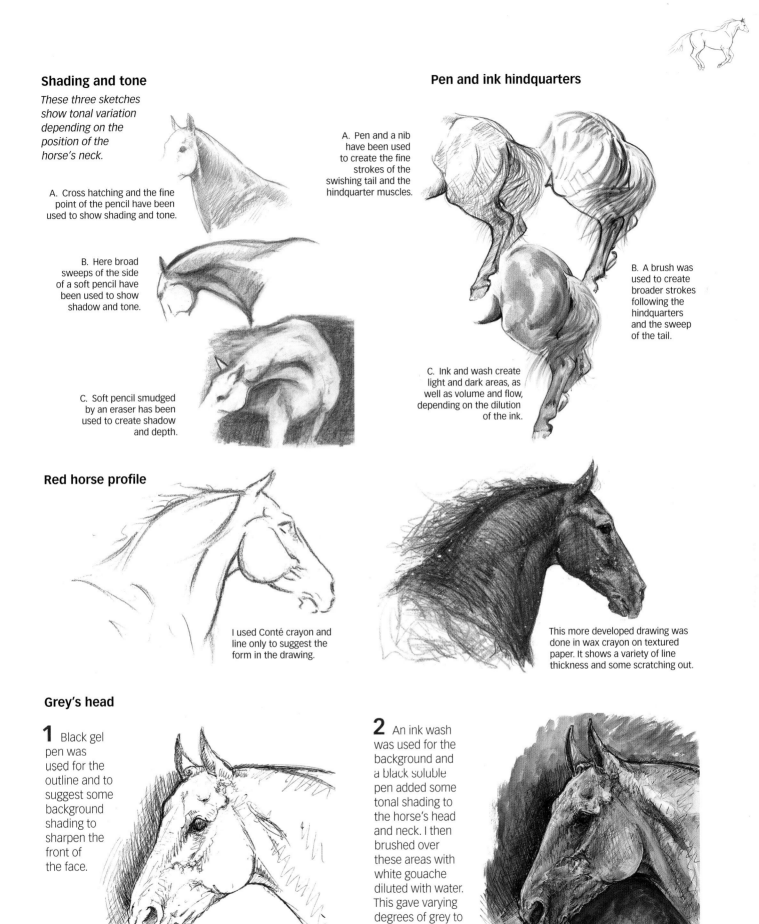

Shading and tone

These three sketches show tonal variation depending on the position of the horse's neck.

A. Cross hatching and the fine point of the pencil have been used to show shading and tone.

B. Here broad sweeps of the side of a soft pencil have been used to show shadow and tone.

C. Soft pencil smudged by an eraser has been used to create shadow and depth.

Pen and ink hindquarters

A. Pen and a nib have been used to create the fine strokes of the swishing tail and the hindquarter muscles.

B. A brush was used to create broader strokes following the hindquarters and the sweep of the tail.

C. Ink and wash create light and dark areas, as well as volume and flow, depending on the dilution of the ink.

Red horse profile

I used Conté crayon and line only to suggest the form in the drawing.

This more developed drawing was done in wax crayon on textured paper. It shows a variety of line thickness and some scratching out.

Grey's head

1 Black gel pen was used for the outline and to suggest some background shading to sharpen the front of the face.

2 An ink wash was used for the background and a black soluble pen added some tonal shading to the horse's head and neck. I then brushed over these areas with white gouache diluted with water. This gave varying degrees of grey to create the volume and contours of the head and neck.

Locomotion

Photographs can be very useful in understanding the correct sequence of limb movements. Before the advent of photography in the late 1800s, most artists thought a galloping horse moved like the one shown on the right, and this was reflected in their paintings. In 1877 Eadweard Muybridge took a series of photographs called 'The Horse in Motion', which were then animated so that people

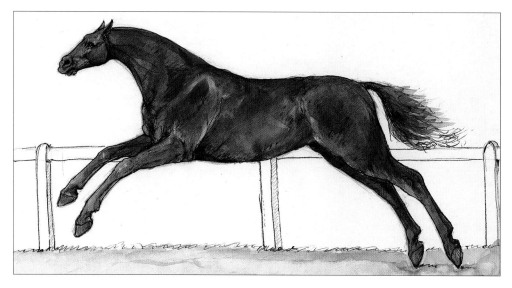

could see exactly the sequence of movements involved. Muybridge also found that a trotting horse can have a moment of suspension when all four feet are off the ground. Reflecting this in your drawings can add a lightness to your work.

The movements of a horse walking, trotting, cantering and galloping are shown below. Note the body, neck and tail movement as well as the legs. In cantering especially, there is a lot of pelvic movement.

Motion diagrams

red = right limbs green = left limbs

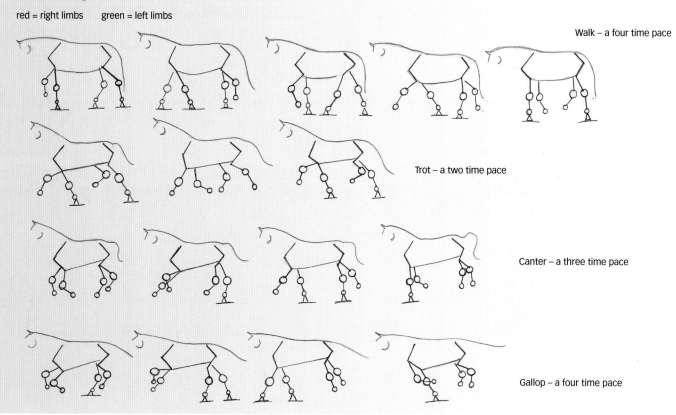

Walk – a four time pace

Trot – a two time pace

Canter – a three time pace

Gallop – a four time pace

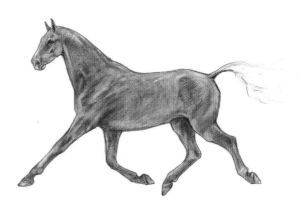

There are variations within these paces, shown below.

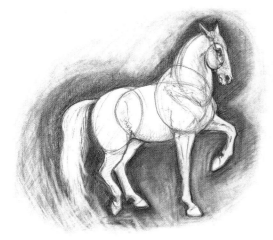

Collected

Moving in collection gives the horse a rounder frame (think of the shape of a rainbow), as well as more elevation to the limbs' movement. Collection consists of bending.

Extended

Moving in extension gives the horse a longer, flatter frame. Sometimes horses playing at liberty will show an exaggerated way of moving, in trot appearing to flick their toes out. Extension consists of stretching. This horse is showing extension in the trot and we also see the 'moment of suspension,' when all four hooves are off the ground.

The tølt

This is a very fast running walk done by Icelandic ponies, which can reach speeds of 56kph (34mph).

There are also a few limb sequence variations. Don't forget that the limbs' attachment to the horse's body does not stop at the horizontal of the belly's underside, but instead goes up into the trunk, giving a range of movement to the shoulders and hindquarters. Look at the skeleton drawing again.

A trotting horse pacing

This tends to be inherent in horses that are bred to compete in trotting races. They will move both legs on the same side forwards when trotting rather than moving the legs in diagonal pairs. Compare with the motion diagrams that show a diagonal trot and the trotting horse showing extension.

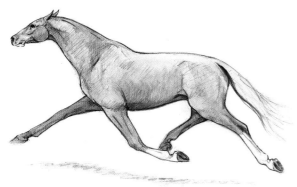

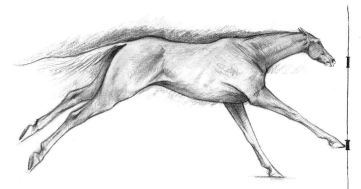

Full gallop

This shows a horse in full gallop with nose and toe extended. Notice how the muzzle of a galloping horse cannot reach in advance of the toe of a front hoof.

Portraying movement

When moving, horses use their heads, necks and to a degree their tails, so try to look at the whole animal, rather than their component parts, or just their limbs in isolation.

Flying manes and tails help to show direction and movement and the tail is carried higher in a moving horse than when still (see page 48).

Be aware of the difference between an extended or flexed limb (see page 48).

You could try blurring lines and even leaving out areas completely, as, remember, this is how your eye will see movement, especially if it is very fast, and you are not trying to reproduce a photographic image. Use quick lines to show tone and shading rather than solid blocks which can slow things down. Remember you are creating an illusion of movement and artistic licence may be called upon.

Horse jumping – Step 1
This shape drawing shows the take off stage of jumping.

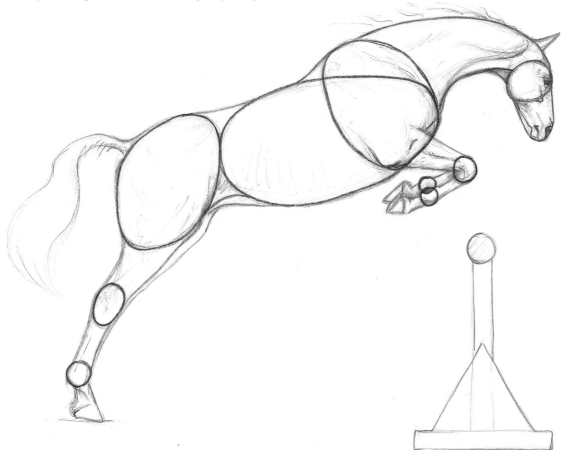

Step 2 (opposite, top)
This shows the flight stage of a jump, and is done as a tonal drawing.

Step 3 (opposite, bottom)
This shows the horse landing and is done as a sketchy painting.

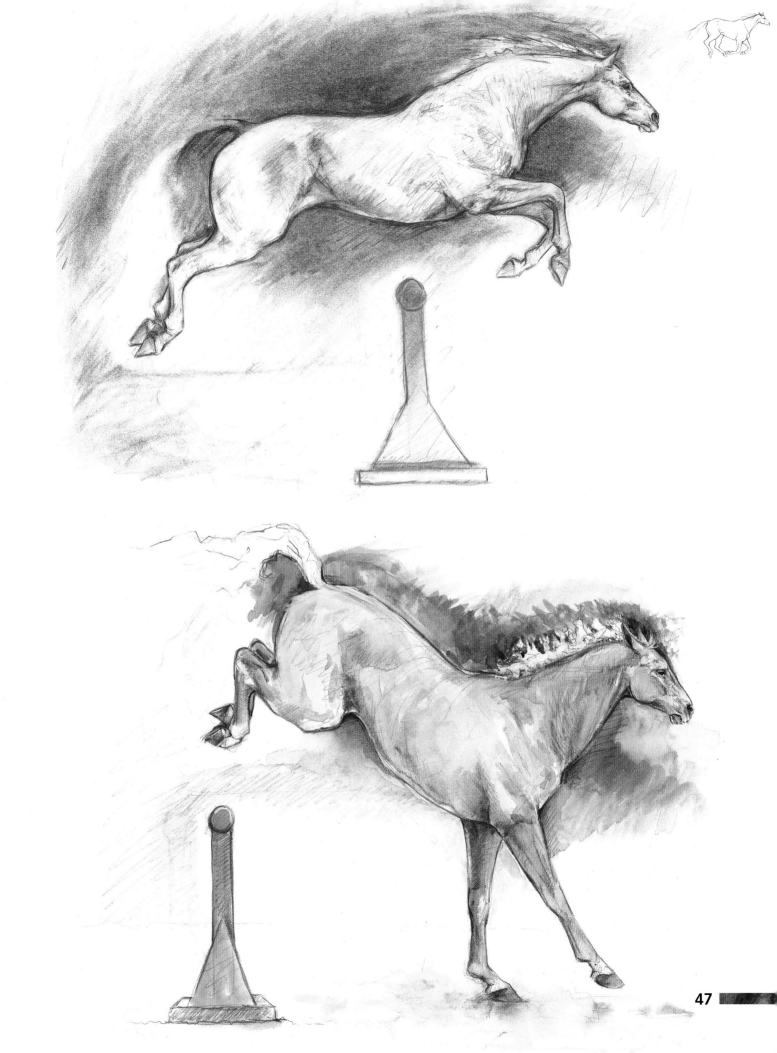

Flying manes and tails

These illustrations show how different media can be used to portray movement in manes and tails. They show, clockwise from top left: charcoal, pencil, watercolour, white gouache and pencil, soft pastel, gel pen and Conté crayon.

Flexed and extended limbs

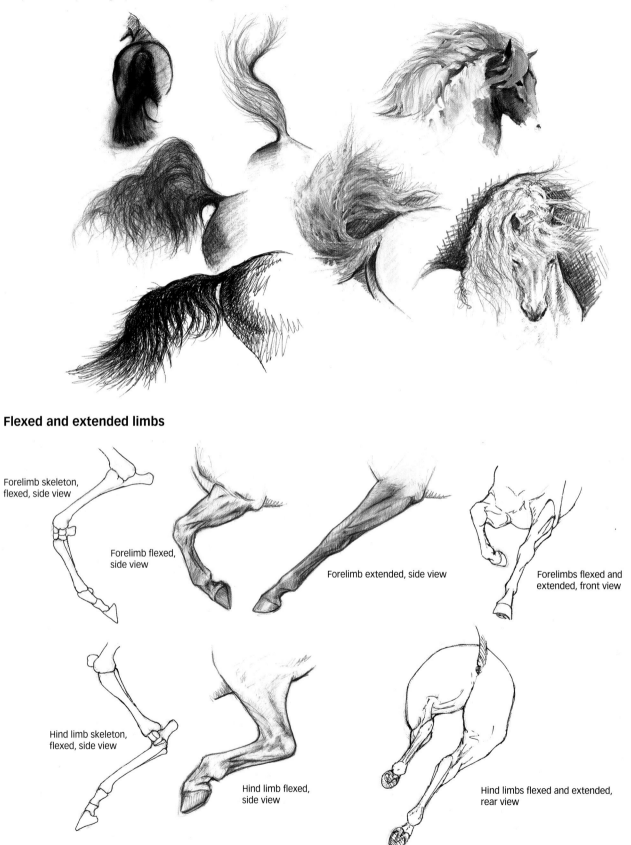

Forelimb skeleton, flexed, side view

Forelimb flexed, side view

Forelimb extended, side view

Forelimbs flexed and extended, front view

Hind limb skeleton, flexed, side view

Hind limb flexed, side view

Hind limbs flexed and extended, rear view

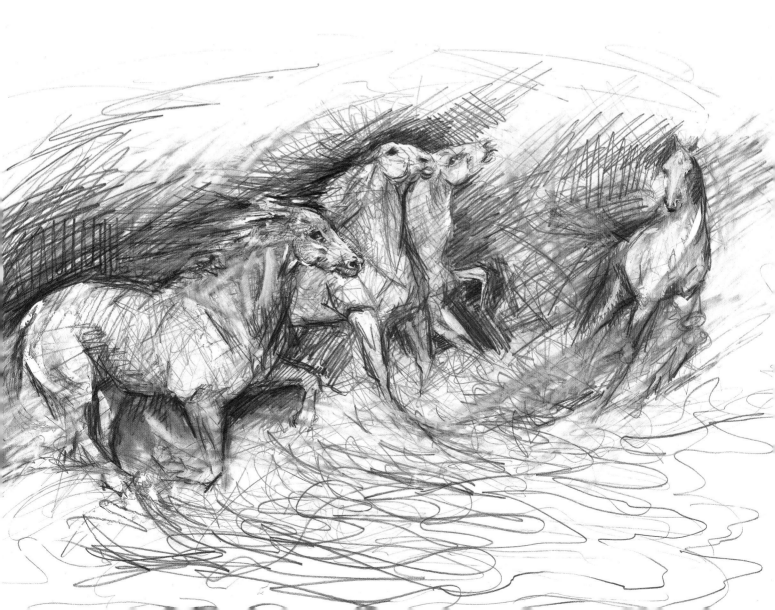

Blurry lines to suggest speed

In this drawing, Sea Horses, pencil was used with an eraser to smudge it, suggesting movement. Highlights were suggested with white gouache to create light and drama.

Proportion

Getting the proportions of the horse correct will help with the overall feel of balance and harmony in your drawings. I stick to very simple guidelines when depicting proportion, preferring to develop 'an eye' rather than rely on measurements that I don't really understand.

Remember, once a horse moves, its proportions can look very different – even simply raising or lowering its neck, and certainly rearing or bucking seem to change everything. Again, we come back to the rule that observation is the best teacher. Your eye will soon learn when something does not look quite right.

Adult horse proportions

Blue lines – head lengths can be used as a unit of measurement.
Red square – Body and legs fit approximately into a square.
Green triangle – the distance from the croup to the stifle to the point of the buttock.
Yellow line – the shoulder should be at 45 degrees.

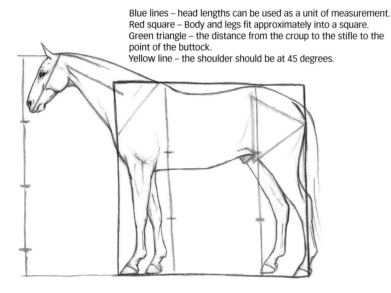

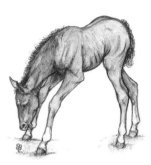

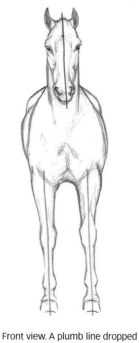

Foal proportions

A foal has long legs compared to its body, and a short neck, meaning that this one has to straddle her limbs to reach the grass.

Different views

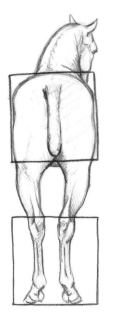

Rear view. The hindquarters will fill a square. The distance from hip to thigh should equal that from hock to ground.

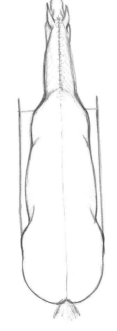

Bird's eye view. This shows how the hips are wider than the shoulders.

Front view. A plumb line dropped through the forelimbs should equally bisect them. The head should show symmetry.

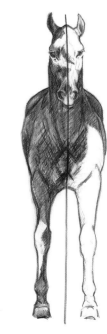

Front view in a horse with markings. Beware of the way in which some markings can appear to distort symmetry and limb length.

Foreshortening

Observation is also the best guide when it comes to foreshortening, where the angle of viewing and distance will all have an impact – exaggerating by elongating or shortening parts of the body. This is why it can be very difficult to make head-on views look convincing, as the animal's head can appear distorted and too big compared to the rest of the body.

In the early stages, try to stick to easier angles from which to draw, rather than losing heart when it all goes wrong.

Hold your pencil at arm's length to help you to measure the angles you need to get right, and use the numbers on a clock face to identify the angles, as shown below. Doing a shape drawing first may help you to see the angles.

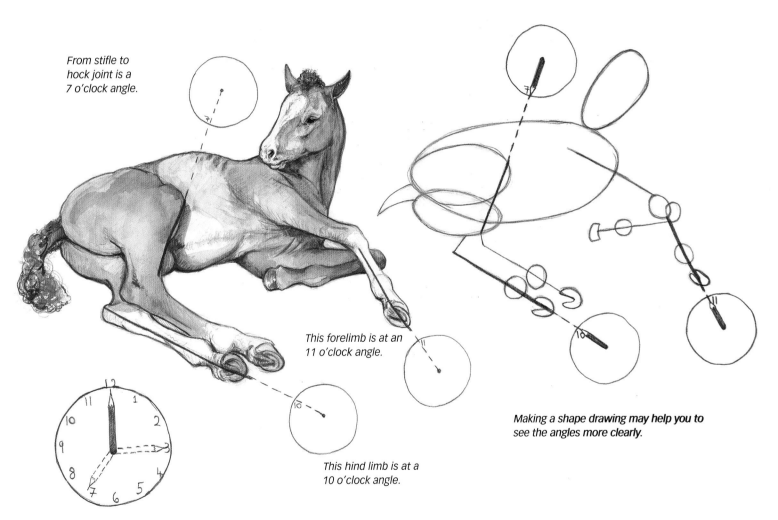

From stifle to hock joint is a 7 o'clock angle.

This forelimb is at an 11 o'clock angle.

This hind limb is at a 10 o'clock angle.

Making a shape drawing may help you to see the angles more clearly.

Conformation

Generally speaking, if a horse has good proportions, its conformation will also be good. This simply means that the head, neck, body and limbs all fit together as they should to allow the animal to function as intended by nature. Have a look at lots of different breeds to see how their size and shape differ.

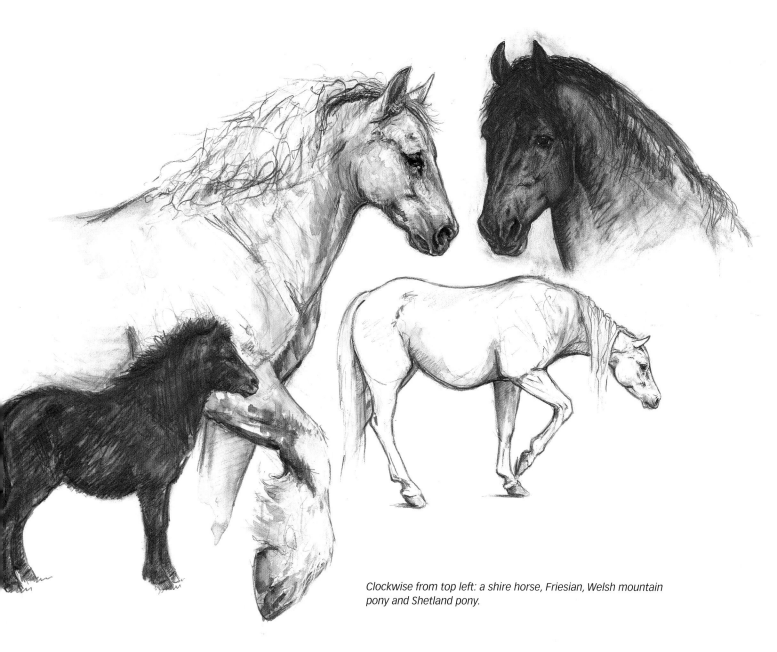

Clockwise from top left: a shire horse, Friesian, Welsh mountain pony and Shetland pony.

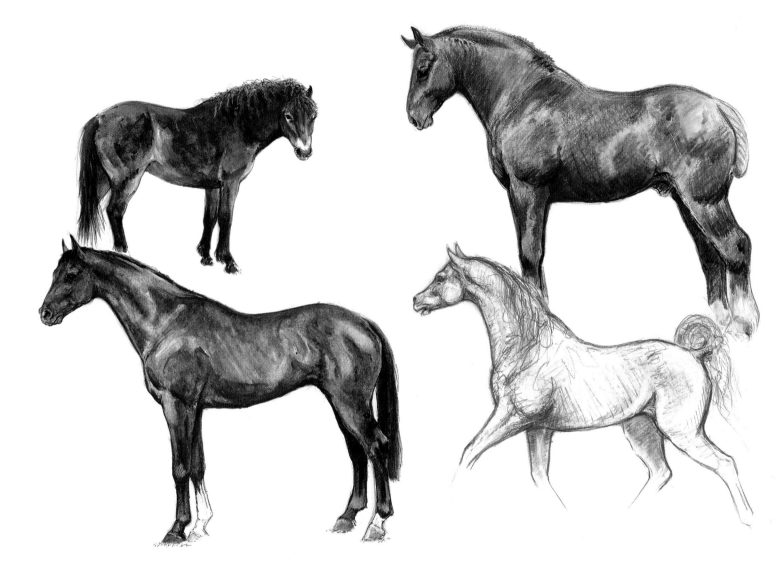

Clockwise from top left: an Exmoor pony, Suffolk punch, Arab and thoroughbred.

Notice how the horses illustrated on these two pages show a great variety in shape and size. Think how you could portray this in your paintings and drawings – what media do you think would work well to suggest the weight and solidity of the shire horse and the Friesian compared to the lighter-boned Welsh mountain pony or the fuzzy-coated Shetland pony? How would you choose to depict the chunky musculature of the Suffolk punch as opposed to the thick mane of the slightly rotund Exmoor? The Arab and thoroughbred are quite similar in body shape, but once they begin moving, they appear very different. Have fun spotting differences and remember that no two horses, even of the same breed, will be identical. Really work at capturing individuals in looks and personality.

Introducing detail

Now, armed with more understanding and practice, your drawings can be developed further by introducing details that will enable them to be used as the final preparatory studies to complete drawings and paintings. Detail will help portray mood, character and personality.

'The look of eagles' is a term used in the racing world for those certain stallions that have a special presence, almost a haughtiness, about them. I have depicted this in the painting below.

Haughty Stallion

This stallion, showing the 'look of eagles', was done in watercolour and pen.

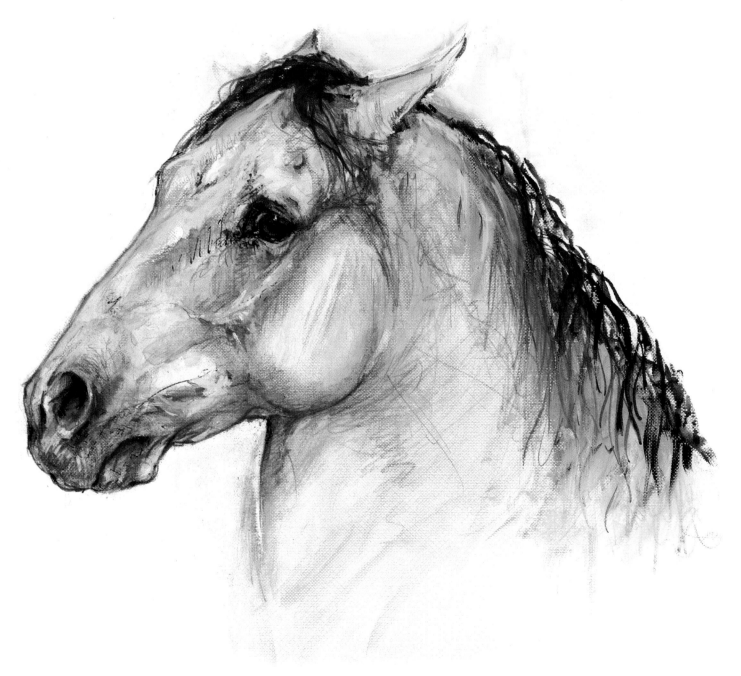

An eye step by step

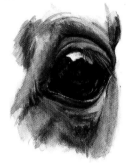

1 Using an HB pencil, draw a circle outlined by the under eyelid and corners.

2 Draw in the upper lid and bony socket above and below the eye. Add a wavy line on the upper eye to indicate reflection and highlights.

3 Add more detail with the pencil, the oval shape of the pupil and the highlighted and reflected areas. Use a light pencil stroke to indicate the lie of the upper lashes.

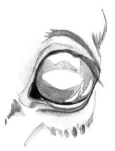

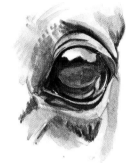

4 Use a size 2 round brush for all the painting. Wash dilute burnt umber on to the eyeball to give colour to the iris, then use Davy's grey and Payne's gray to define the lids and upper eyelashes. Leave the inner edge of the lower lid lighter. A sepia tint 'drawn' with the brush outlines the corner and eyeball. Use brush strokes of burnt sienna to add detail to bony protuberances on the upper eye and the edge of the socket under the eye. Add a touch of Van Dyke brown to define the eye's inner corner.

5 Add the pupil with dilute Payne's gray. Above this use Van Dyke brown, following the highlight's border. Below the pupil use burnt sienna, blotting it out where reflection and highlights are indicated. Define around the eye socket with burnt sienna for the hair colour. Mix it with a little Winsor violet to help create the eyelid creases in more depth. Strengthen the lower lid with a mix of Payne's gray and Davy's grey. A pale cerulean blue wash suggests sky on the right-hand side of the highlight.

6 Build up with brush strokes using less dilute burnt sienna around the eye and on the face to help create the illusion of contours and protuberances. Add a touch of burnt umber to the eye's inner corner and below the eye on the edge of the bony socket. Darken the lids with Payne's gray, being careful to leave a lighter strip on the lower lid to suggest moisture. Darken the iris with washes of burnt umber and blot highlighted areas to keep them paler. Finally, using fine brush strokes of Payne's gray, define the upper lashes, using tiny amounts of diluted white gouache to draw individual hairs.

Different eyes

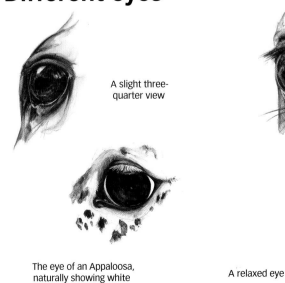

A slight three-quarter view

The eye of an Appaloosa, naturally showing white

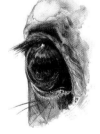

Front view

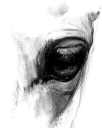

A relaxed eye

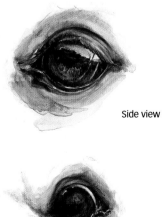

Side view

A frightened eye showing white

Ear positions

The ears of a horse are very mobile: they rise, fall and rotate to a degree so can alter their whole appearance very quickly. They show where attention is directed, often in conjunction with the eyes. Make a cone out of paper as shown below to help you find the position of the ears on the head you want to depict.

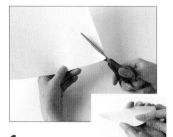

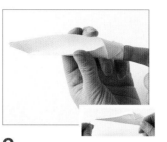

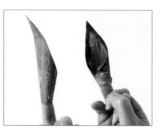

1 Cut out an isoceles triangle from card or paper. Curl the triangle round your finger.

2 Stick the ear shape with masking tape and squeeze the sides in a bit to shape it further. Flick the tip back a little.

3 I have painted these ears for a more realistic effect. You can hold them at different angles and in different positions to help you in your drawing.

What ear positions show

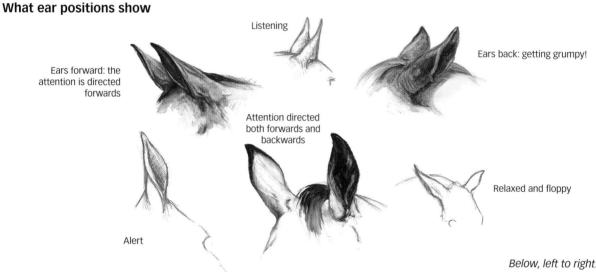

Listening

Ears forward: the attention is directed forwards

Ears back: getting grumpy!

Attention directed both forwards and backwards

Relaxed and floppy

Alert

The muzzle

This is comprised of the nostrils, lips and chin. Look for lines of tension like a thin cord behind the lips, below and behind the nostrils. Flaring nostrils can show alarm. The chin can be drawn into a tight ball by a tense horse, or floppy and loose in a relaxed one. By building up a complete picture like this, you are revealing the unseen essence, spirit or character of the horse; you are bringing it to life.

Below, left to right: a relaxed muzzle with floppy lips and chin; a tense muzzle with the chin in a tight ball and tension lines around the lips and nostril; a worried muzzle with snorting nostrils showing the pink inside; flared nostrils from alarm or exertion.

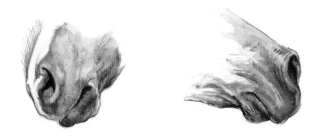

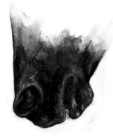

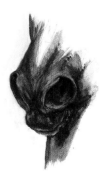

Unshod hoof

Shod hoof

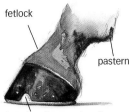

fetlock

pastern

shoe showing quarter clip

Hooves

One area I would like to pay a little attention to is the inside and rear of the hooves. So often they are portrayed as solid objects, whereas in reality, if you look at the underside, they are usually slightly concave with a hard rubbery 'V' shape, called the frog, dividing the two halves of the hoof down the centre. You will only see this if drawing a rear view, but it is a point worth noting.

Unshod hoof underside

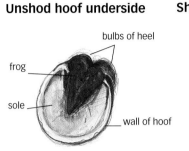

bulbs of heel

frog

sole

wall of hoof

Shod hoof underside

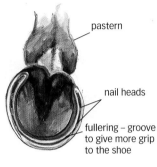

pastern

nail heads

fullering – groove
to give more grip
to the shoe

Rear view

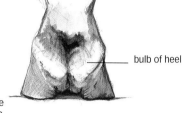

pastern

bulb of heel

Markings

We look in greater detail at colours and markings in the final section but, for now, markings can be positioned by the use of line or tonal shading to suggest their boundaries. Written notes can help with explaining which direction light is coming from and also the direction of the lie of the coat and time of year, as this will all affect the final painting's outcome.

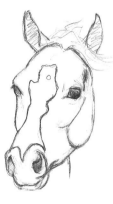

A blaze on the face, shown
by line

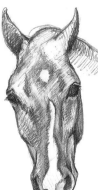

A star and stripe
boundary shown
by shading

Sock and ermine
marks shown by line

Sock and ermine marks
shown by shading

Foal showing coat details

The red marks show where whorls may be. The arrows show the direction of the lie of the coat hair, which is like this to help drain rainwater off the horse's body.

Limb movement

The sticks and circles can be a framework on which to build up your drawings of horses in motion, or you can simply use them as a guide to aid your understanding of the way horses move.

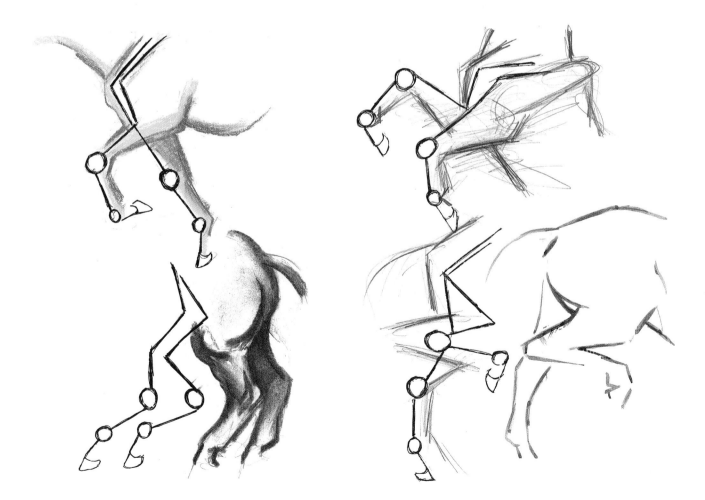

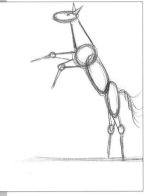

- Make a flipbook of a moving horse. Use a small notepad with paper that is not too thick. Draw a ground line to position the horse, and make sure this is the same height on each page. Draw the horse shape in whatever position you like, keeping each one the same size. Successive images should portray a range of movement such as walking, trotting, cantering, galloping, kicking, rearing or bucking. Flip through the book and you will see the movement.

Flipbook images of a rearing horse

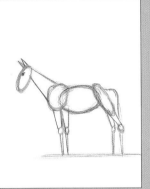
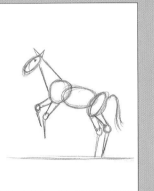
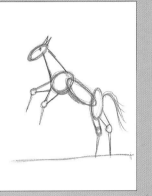
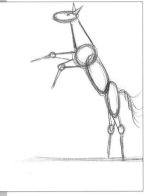

Flipbook images of a galloping horse

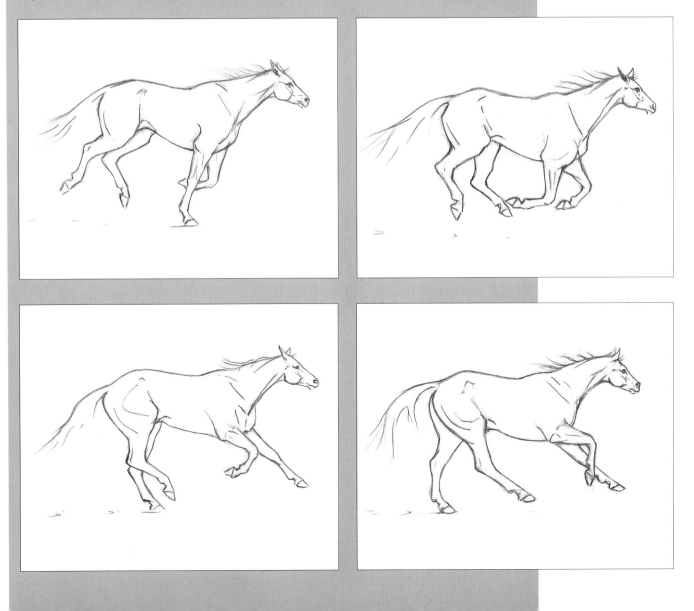

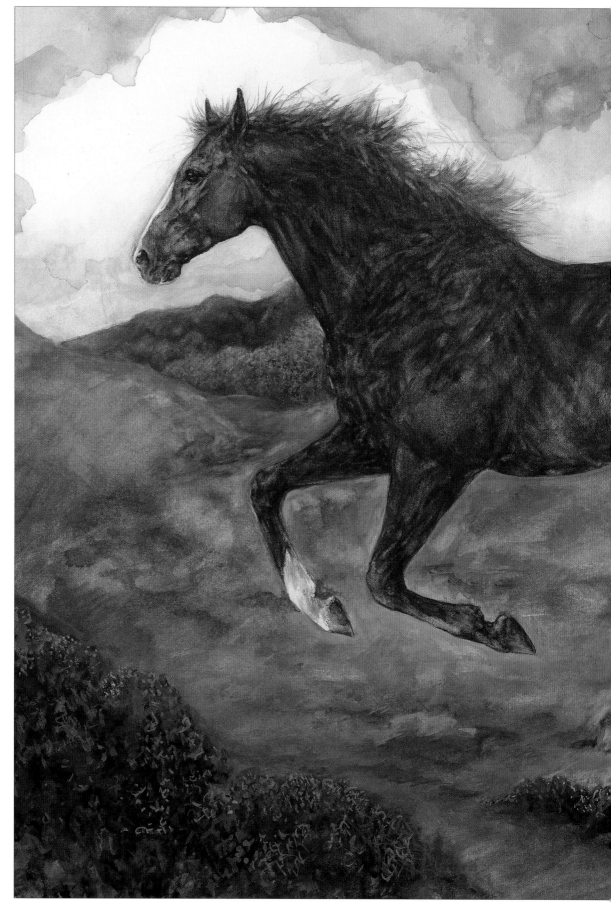

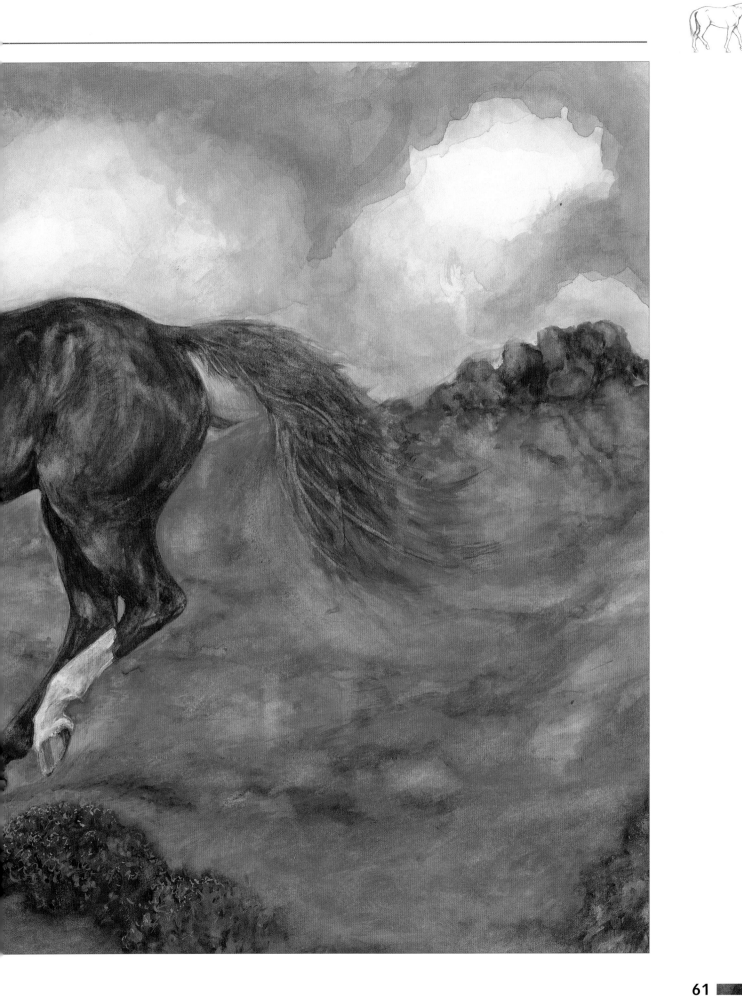

Your work space

So, how do we get from sketchbook to studio? Well, for a start, do not be put off by the term 'studio'. It sounds rather grand but it is just a work space. It could even be the kitchen table, or a quiet corner in a sitting room. It is better though, if you can find somewhere you will not have to tidy up every time you finish working.

Reasonable lighting helps, ideally natural daylight, but you can easily buy daylight simulation bulbs, meaning that you can work through those long, dark winter evenings, instead of watching television.

You will also need enough space to position an easel, or find a way of propping up a board or canvas, enabling you to step back from it to view work in progress.

A mirror is useful to check work through all stages; it gives a fresh eye because you are looking at a reversed image, and this often highlights areas you need to improve on.

So gather together all your work to date, spread it about along with any other reference material you require, and scrutinise it closely as you begin to plan the final piece.

This is me in my 'artist's garret', working on a composition colour sketch of Katmandu, one of the horses that features throughout this book. I always have Stubbs' Anatomy of the Horse *by me as reference when working, as well as other books. Look at the messy state of my watercolour palette; try to keep yours cleaner when working so that the colours do not get too muddy. I keep a clear area in front of my easel to enable me to push it forward and view work in progress from a distance. I work both standing and sitting with studio paintings – find what works best for you.*

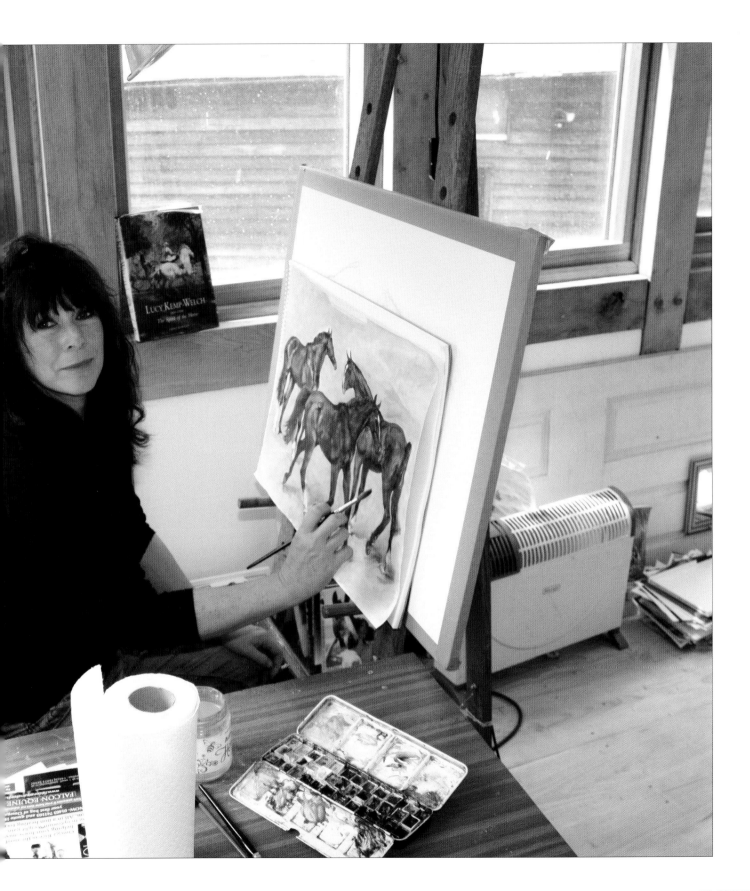

Composition

Look critically at your work to date – you may find you still need to do some more drawings or collect more information. There's no reason why, even when working on the final project, that you can't keep adding to your sketchbook studies. It is an ongoing learning process.

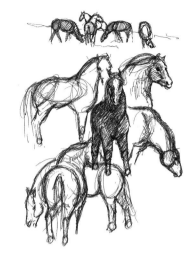

Begin to work out your composition. Do this on cheap paper as most ideas will not be used. I find lots of thumbnail sketches on one sheet of paper help (see right) as, you can compare the images.

Ask yourself lots of questions. What size paper will you paint on? How many horses are included? Is it a head and neck only portrait? What scale is everything in? What creates a balanced, harmonious image? Are you including a background? Is there a narrative taking place?

Try using a window mount (simply a card rectangle with a window cut out) to look at your work through. It helps to isolate areas, letting you focus on what works and what doesn't.

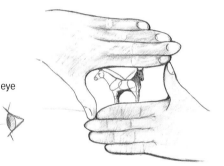

sketchbook

Using a window mount to view your sketches.

A viewing frame made with the hands.

Your hands can also make a viewing frame, which is especially useful when you are drawing from life.

Why not have a go at using a window mount, or your hands, to view the two sketches (left) of ponies in their hilly habitat. See if you can select the best composition. Look for rhythm, harmony and balance.

You could also use these sketches of individual herd members (right) to have a go at creating your own hill pony group, once again looking for the best composition.

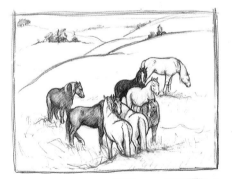

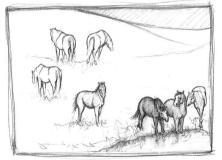

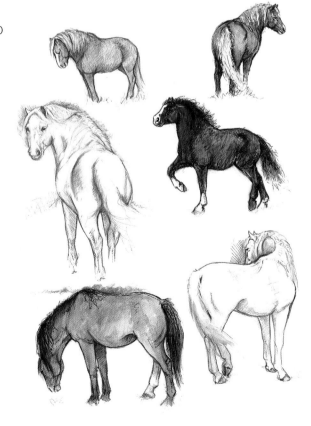

Individual horses.

Backgrounds

While this book does not focus too closely on painting backgrounds, it is important for you to be aware of and sensitive to the difference a background can make. You might decide that a simple coloured wash is all you require. Have a look at Stubbs' portrait of Whistlejacket, originally intended to have a background, which he later decided against. Ask

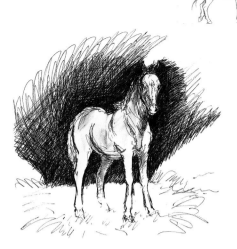

yourself, do you want a detailed background, or one that blurs and suggests speed? Perhaps you want to show the home environment of a particular horse that belongs to a friend. What are the weather conditions like, the time of year, even the hour of the day? All these things will impact greatly on the horses themselves. Try to make a plan before you embark on the final painting, as depending on what

media you use, it may be difficult to alter once you have begun.

Basically, your background should create atmosphere and interest while not detracting from the main subject.

Both these sketches of foals were drawn quickly from life with black gel pen, and have sketchy backgrounds.

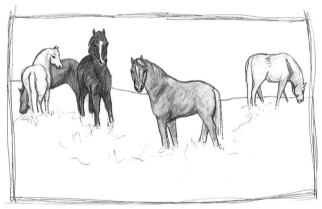

This drawing of hill ponies has a sketchy background.

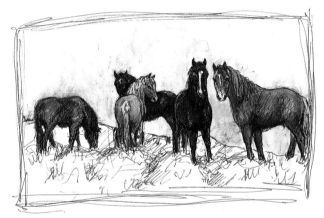

This second drawing has an improved composition and more detail. The background has been put in with scribbles in pen.

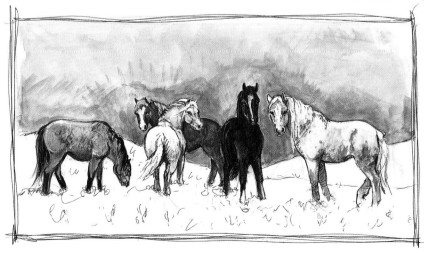

The third drawing has become a snow scene, with a simple colour wash for a background. This could have been used to create a more complete painting.

Colours and markings

There is a vast range of coat colour in horses, all absorbing and reflecting light differently, so be very aware of light sources in your work. Another consideration is the time of year. If it is summer, you would be unlikely to paint a horse that shows lines where they have been clipped. Winter coats tend to be fluffier than sleek, glossy summer coats, so they do not gleam as much. Is he a hairy Shetland or a sleek thoroughbred? Has the horse been working? The coat may look darker due to sweat, especially on the neck and quarters. I have tried throughout the book to show as many different coats as possible. I bet you can find more of your own!

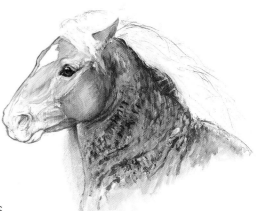

A horse with its neck sweated up. Note that this shows as rough looking, with creases forming where sweat has dried, creating a difference between the light and dark of the wet and drying neck. I used dabs and smudges of paint to show this.

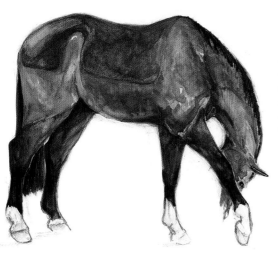

A horse showing a blanket clip. Note the tonal and colour differences between the redder, unclipped hair and the greyer tones of the clipped areas where the skin colour shows through.

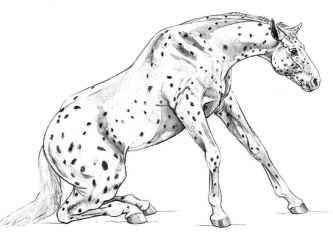

A leopard spot Appaloosa. Note how the spots get larger towards the rear of the animal, especially on her hindquarters.

A blue roan (left) and a flea-bitten grey (right).

The very hairy, rough-textured coat of a pony kept on the hills in winter. The pen has been densely scribbled and pressed hard into the paper.

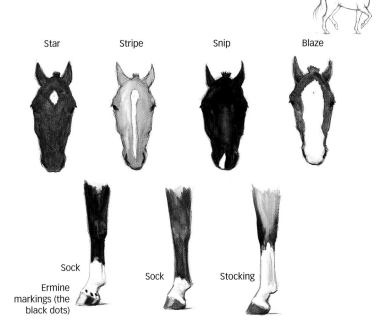

Markings too take many forms. Some points to look out for are coat patterns, e.g. skewbald or piebald markings can give a slightly distorted look, especially on the face and legs. White markings that extend very high on the legs can make limbs look disproportionate to the body, so you need to decide whether to paint what you see or use a little artistic licence. Markings often enhance the look of a horse and can disguise defects as well.

White areas on a horse are not truly white! Look closely – do they have pink skin showing through? Is it a grey horse with dark skin? Any white areas will show variance: bits of shadow, tone and shade in nooks and crannies. They are never pure white, and would look flat like a cut-out if portrayed as such.

Manes and tails can be the same colour as the coat or contrasting, but because of the textural difference, even the same colour will appear slightly altered.

Star Stripe Snip Blaze

Sock Ermine markings (the black dots) Sock Stocking

Face and leg markings

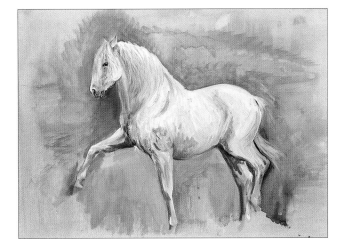

White areas

This horse has a grey skin and white hair. Look closely and note how there are actually no pure white areas, except where there are highlights.

Eye colour

Eye colour varies little, normally being different shades of brown, very occasionally flecked with an almost amber pigmentation. Some horses have wall eyes that lack brown pigmentation and show as china blue. There is no such thing as an albino eye in the horse.

Be very aware of where the highlights in the eye appear, as this can totally alter the whole mood of the horse. Again, highlights are not truly white – shown as such they give an unnatural feel.

The lens of the eye is spherical, so light can make part of the eye look almost hazel while another area appears dark brown. The pupil is elliptical and an inky blue; its size alters depending on brightness.

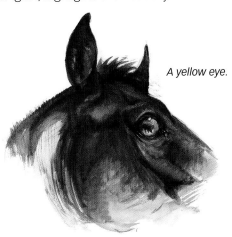

A yellow eye.

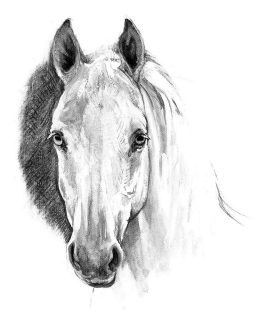

A cremello horse – they always have blue eyes and pink skin. The blue is a lack of pigmentation, also known as wall eye.

Mixing colours for coats and manes

The following colour swatches show good mixes for different breeds of horse. They were done in watercolour, either as a wash or by stippling. The manes were done with brush strokes.

Black – the coat is neutral tint; the mane also neutral tint, highlighted with a mix of white gouache and Payne's gray.

Iron grey – the coat is neutral tint; the mane also neutral tint, highlighted with a mix of white gouache and Payne's gray.

Brown – the coat is sepia and Van Dyke brown; the mane neutral tint and sepia.

Bright bay – the coat is burnt sienna; the mane is neutral tint and Payne's gray.

Yellow dun – the coat is raw sienna and yellow ochre; the mane is sepia tint and neutral tint.

Mouse dun – the coat is Davy's grey, burnt sienna and Naples yellow; the mane is burnt sienna and sepia tint.

Piebald – the coat is white gouache, neutral tint and sepia; the mane is also white gouache, neutral tint and sepia.

Skewbald – the coat is white gouache and burnt umber; the mane is white gouache and burnt umber.

Blue roan – the coat is Payne's gray and white gouache; the mane is neutral tint.

Dapple grey – the coat is Davy's grey and white gouache; the mane is white gouache and Naples yellow.

Chestnut – the coat is raw sienna and burnt sienna; the mane is raw sienna and Naples yellow.

Strawberry roan – the coat is burnt sienna, dioxazine violet and white gouache; the mane is burnt sienna.

Palomino – the coat is Naples yellow and white gouache; the mane is white gouache and burnt sienna.

Flea-bitten grey – the coat is burnt sienna, Payne's gray and dioxazine violet; the mane is white gouache.

Appaloosa – the coat is Van Dyke brown; the mane is white gouache and sepia tint.

White showing dark skin (technically called grey) – the coat is Davy's grey overlain with white gouache; the mane is white gouache.

Painting techniques

All these techniques are carried out working upright on an easel.

Graduated wash

This can be used to suggest background landscape, or to depict variation of tone in coat colour.

1 Use a no. 10 sable mix brush to paint on a wash of burnt sienna, brushing from side to side.

2 Darken the area from the top, letting the very wet mix run down. Dry the brush on kitchen paper and use it to lift out a bit of colour at the top.

3 Use the brush to lift off some of the bead of paint at the bottom and drag this upwards.

4 Darken the area a little more at the bottom and leave it to dry naturally.

Veils of colour

This creates volume and mass, as darker areas suggest shadow. Also good for delicately building up tone and colour but retaining transparency, e.g. in the eye. Use for subtly building up contours and hollows, e.g. definition between muscles on shoulders and hindquarters.

Blotting

This can be used to add a shimmer to a glossy coat.

1 Paint on a dilute, very wet wash of cerulean blue.

2 Add a little Payne's gray on half of the area, while wet. Allow to dry naturally.

1 Paint on a thick wash of raw sienna.

2 Crumple and fold a piece of kitchen paper and dab at the wash to lift out paint in places.

Painting a sky

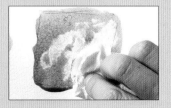

1 Paint on a fairly dilute wash of cobalt blue, and blot out clouds with kitchen paper.

2 Drop a stronger mix of cobalt blue and Payne's gray into the blue area. It will stop on the edge of the drier area, creating a stormy effect. Dry the brush on kitchen paper and lift out any large drops.

Scumbling

The effect achieved is good for painting the coats of woolly native British breeds.

1 Use thick burnt umber on a dry brush. Scribble, drag and press the brush to create texture. Use older brushes.

2 Layer thick yellow ochre on top.

Wet scumbling

This is great to show a horse's coat sweated up or wet from splashing through water.

1 Use the same technique as for scumbling but with much wetter paint; raw sienna is shown here. This creates a bubbly effect.

Stippling

This technique is good for dappled coat texture or for foliage, undergrowth or light and shade.

1 Use a no. 4 synthetic brush and fairly dry terra verte, and dab with the end and side of the brush. As you unload paint, the splayed brush hairs will create more texture.

2 Continue with another layer of stippling.

3 Add a layer of Naples yellow in the same way. You can work wet on wet for a smudged effect.

Pointillist stippling

This technique gives you plenty of control when creating variations in muscle tone, or the shape of a shoulder blade.

1 Use the no. 4 brush fairly dry with Van Dyke brown, and stipple dots with the point of the brush. The effect will become paler as the paint unloads.

2 Change to cadmium red for contrast and continue stippling dots between or overlapping the previous ones.

Dry dragging

This technique is good for creating shadow and tone that does not need to be blocked in too harshly.

1 Load a no. 10 brush with dry burnt sienna and a little Winsor violet, and drag the colour down. Load again and continue, then drag across from side to side.

2 Darken some areas.

Streaking for manes and tails

This technique is useful for painting white horses.

1 Use a no. 6 brush to apply permanent white gouache straight from the tube, stroking it downwards.

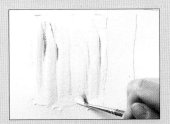

2 Use a no. 4 brush with dilute raw sienna, streaking the colour downwards so that it picks up the white.

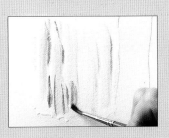

3 Paint streaks of neutral tint with only a bit of water on the lower part of the mane.

4 Continue adding streaks of white gouache and more colour until you are happy with the effect.

Scratching out

This technique can be used to create texture on coats and on tail and mane hair, and to add drama to a scene.

 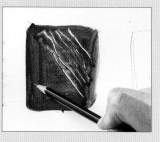

1 Use the no. 10 brush to apply burnt sienna thickly. While it is quite wet, use your fingernail to scratch into it.

2 You can also scratch out with a hard 2H pencil. This takes paint off and scores the paper.

Using wax crayons with watercolour

The wax crayon creates a resist and watercolour does not take over it, creating a textural quality which is useful when depicting dynamism, movement, fighting, racing and playing.

 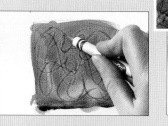

1 Paint on dilute neutral tint with the no. 10 brush. While it is wet, scribble on top with a wax crayon in a similar colour, pressing hard in places to make indentations.

2 Apply another veil of paint on top.

Pencil drawing under paint

This method is good for emphasising muscle definition and features such as tendons and ligaments.

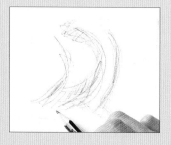 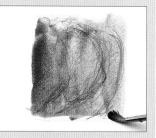

1 Scribble the feature you are drawing with an F pencil, which is quite hard.

2 Use a no. 6 brush to paint over it with sepia tint.

Pencil drawing over paint

This is a good method to use when sketching live as you can block in colour, then define the image with pencil.

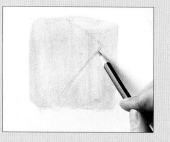 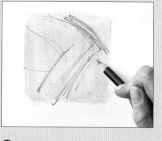

1 Paint on Naples yellow with the no. 6 brush, allow it to dry, then draw with an F pencil on top.

2 Change to a softer 4B pencil and continue drawing darker lines.

Broad pencil techniques

These might be used for unusual markings on horses.

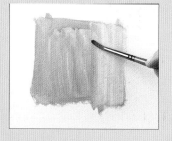 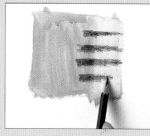

1 Use the no. 6 brush to paint on a mix of cadmium orange and raw sienna. Dry the brush and lift off paint on one side.

2 Use the flat part of a 6B pencil lead to create broad marks, like the eel markings on some horses' legs.

Dark hooves

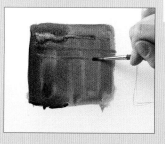 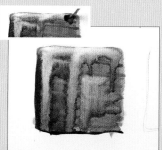

1 Apply sepia tint and raw sienna with the no. 10 brush, then add Payne's gray on the left and let it merge. Use the no. 4 brush to drag dark lines across the area.

2 Paint a band of clean water across the top and allow it to run down. Allow to dry naturally.

Light hooves

This technique works for the hooves of lighter coloured horses.

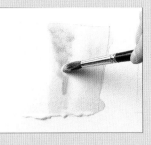

1 Block in the area with Naples yellow on a no. 10 brush, then paint over half the area with white gouache.

2 Darken a strip with Davy's grey and Payne's gray, then strengthen with Davy's grey, letting the paint run down. Allow to dry.

3 Use the no. 6 brush to apply a mix of raw sienna and Naples yellow over the dried paint.

The finished hoof effect.

Foreground, middle ground and distance

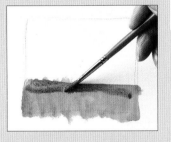

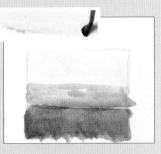

1 Use the no. 6 brush to paint a fairly strong mix of green gold and permanent sap green in the foreground. Add a hint of burnt umber on top.

2 Paint the middle distance with a dilute, bluer mix of terra verte with a little cobalt blue, then the distance with a watery wash of cerulean blue.

Flicking

This can be used to create the effect of loose soil, sand or dust flying around moving hooves.

1 Dip a no. 4 brush in a watery mix of raw sienna and Naples yellow and flick it towards the paper.

2 Next flick on Payne's gray, then permanent rose to create contrast.

Mingling

This is useful where horses have coats of varying colours but you do not want a defined edge to the colours.

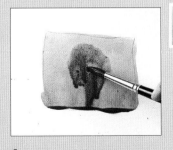

1 Apply wet terra verte, then while this is very wet, paint on a blob of wet cadmium red.

2 Add cadmium yellow in the same way, allowing it to run. Turn the board upside down to let it run in the other direction too, then allow it to dry.

Drawing with a brush

This is useful for modelling skeletons, muscles, tendons, ligaments and other anatomical structures.

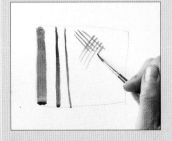

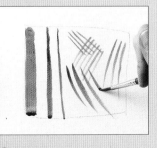

1 You can draw varying downward strokes with a no. 10, no. 4 or a no. 2 brush, using burnt umber. Cross hatch with the no. 2 brush.

2 Paint tapering strokes by applying less pressure at the end.

Here are some demonstrations for you to have a go at. Don't forget that prior to these in this book there is plenty of background information and reference material, and these should be the foundations to the originality and character of your work. Once you have gained some confidence and understanding, you can get out there and create your very own horse drawings and paintings.

Saffron
38 x 28cm (15 x 11in)

This is a head and neck portrait of a thoroughbred mare who was about fourteen years old when I painted her. Her owner, Sheila, commissioned this painting knowing that sadly she had to sell Saffron, whom she adored. Happily though, Saffron has gone to a lovely home and Sheila has been able to keep in contact with the new owners.

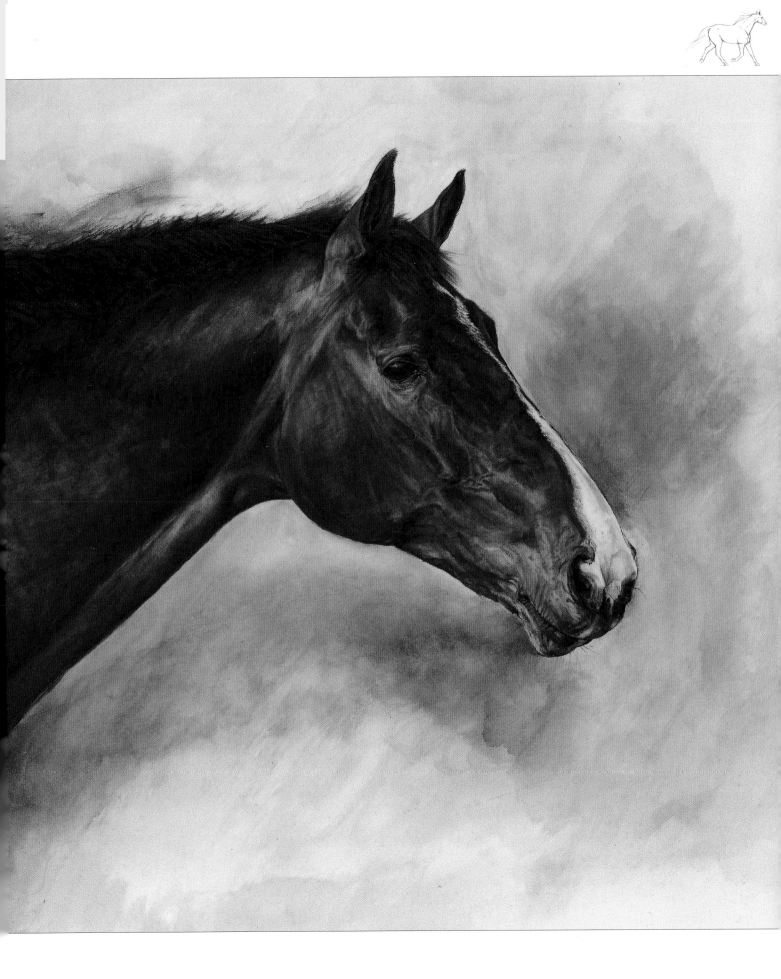

Katmandu

This head and neck portrait shows Katmandu, a Dutch Warmblood gelding. The photograph and sketch were done as he was watching his owner approaching, when he felt sure there would be a treat for him – hence the alert expression and the ears pricked forwards with anticipation. Notice how much emotion is shown in his head and neck position. He was competition fit when this portrait was done and shows a beautiful summer coat.

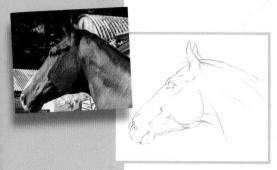

You will need

300gsm (140lb) Hot Pressed watercolour paper

F and 2H pencils, eraser and sharpener

Watercolours: burnt sienna, sepia tint, Payne's gray, Davy's grey, burnt umber, Winsor violet, raw sienna, Van Dyke brown, neutral tint, cerulean blue

White gouache

Brushes: no. 10 round sable/ synthetic, no. 6 and no. 4 synthetic

Kitchen paper

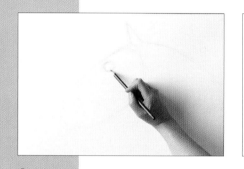

1 Use an F pencil and look for a point to mark on the paper to help you begin to gauge distances, such as the point of the ear, then draw loosely and lightly around this. Block in the main outline of the profile, simplifying into shapes. Establish the next anchor point, the eye, with a simple circle.

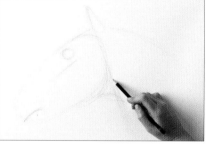

2 Establish the facial crest (like the cheek bone) one-third from the top, then run this line down and go slightly lower to draw the mouth. Run a line down from the point of the ear, and this should establish the line of the underside of the neck.

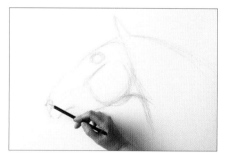

3 Redefine and build shape and structure, emphasising the cheek. With this view, looking up at a seventeen hands horse, you can see a bit of the opposite cheek under the jaw, so put this in. Change and move any lines, reassessing as you go. Add the nostril with the top just above the level of the cheekbone.

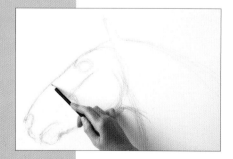

4 Start to add the muzzle, lips and chin. Add a prominence for the eye and bring the front of the nose in from the initial oval shape.

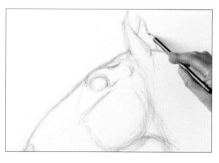

5 Mark the hollow just behind the eye on the forehead. At the back of the eye, add the prominence above the cheekbone and lumps in front of and below the ears. Add another ear.

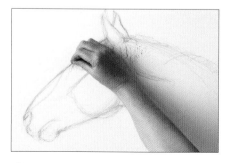

6 Add definition to the big muscles of the neck, and suggest where the mane lies and the white stripe on the face. Erase to lower the lines a bit.

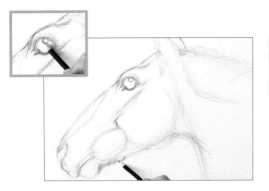

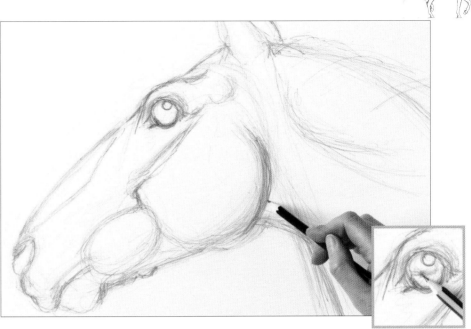

7 Model the eye socket and eyeball. Sharpen the pencil and draw a circle on the eyeball for a highlight at top right, making it larger than you will eventually need. At the end of the facial crest, put in a downwards prominence. Add an oval-shaped area behind the lips, as this should be a little puffed out, and a couple of fleshy lumps under the jaw.

8 Moving down from the prominences behind the eye, model the rounded back edge of the cheek, where the jawbone is near the skin's surface. Place a dark mark in the eye to show where the pupil will go.

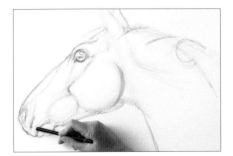

9 Suggest the forelock, three tufts and a curl on the mane with rough shapes. Redefine the chin and jaw and put in the inverted triangle under the eye, ending just in front of the facial crest. Add a groove under the nostril; this can change with a horse's expression.

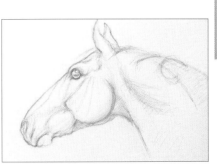

10 Put in the fleshy parts under the lower jaw and begin to add tension lines in the cheek, as finer bred horses are thin-skinned here. Add tonal shading at the back of the cheek and down the neck to show the muscle definition of this fit horse. Further define round the eye to complete the drawing stage.

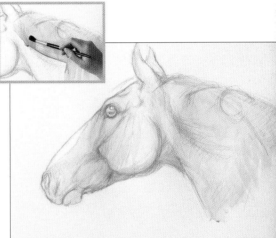

11 This is a bright bay horse, so block in a wash of very dilute burnt sienna with the no. 10 round brush. From the beginning, try to 'feel' the muscle mass under the skin, using the brush in the direction of the muscle. Leave white for the nostril, face marking and highlight in the eye.

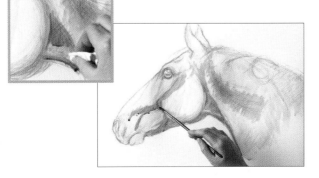

12 Use a no. 6 brush and a stronger mix of burnt sienna, drawing broadly and scribbling with the brush to form the muscles and darker hollows. Blot out any areas that need to be lighter, such as the jugular area. Continue defining the musculature with tone.

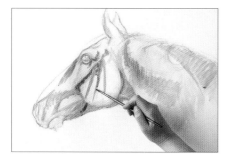

13 Add definition around the muzzle and eye, the bony ridge behind the eye and the facial crest, and paint tension lines on the cheek. Leave to dry naturally.

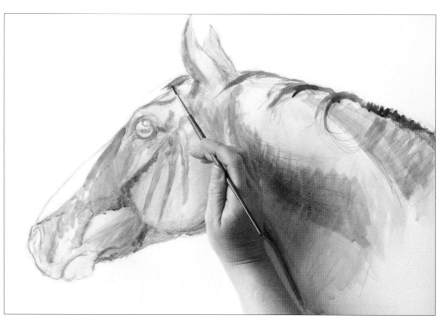

14 Use the no. 10 brush to add paler tone, drawing and washing with the brush. Block in the mane and forelock with the no. 4 brush and sepia tint, with loose, free brush strokes.

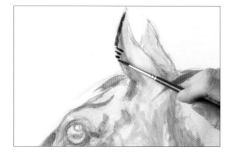

15 Bright bays have darker tips on their ears, so use the brush on its side to suggest dark tufts.

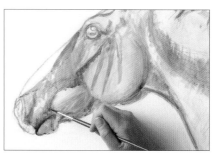

16 Paint the mouth with a dark mix of Payne's gray and Davy's grey, then block in the grey, hairless area of the muzzle. Define the outside of the nostril and bleed the paint out into the surrounding colour with sweeps of the brush.

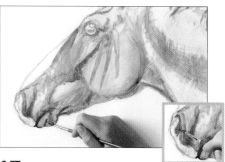

17 Define the chin with a darker mix of the same colours; the shapes here depend on how tense or relaxed the horse is. Darken the inside of the nostril with Davy's gray and burnt sienna, drawing with the brush.

18 Add definition around the eye with Payne's gray and Davy's grey. Paint the pupil.

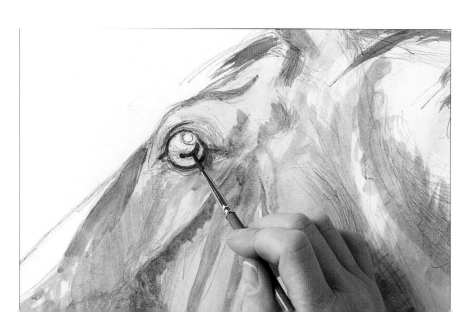

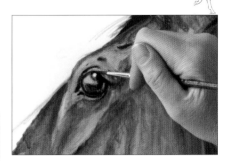

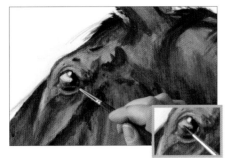

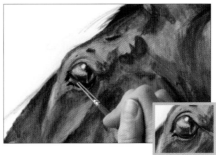

46 Add dilute Van Dyke brown above the pupil, allowing it to run, then put pure Payne's gray on the pupil. Lift a little paint out of the white area of the eye, then scumble on a little raw sienna to take off the whiteness. While this is wet, drop in a tiny bit of cerulean blue.

47 Define the lower lid and corner of the eye, drawing delicate strokes with sepia tint and a little Payne's gray. Suggest the rims of the eye and the eyelid. Paint eye lashes with Van Dyke brown, going down to the outer edge of the eye and out into the socket.

48 Add more burnt sienna with a little burnt umber in the brown part of the eye.

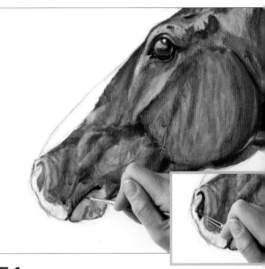

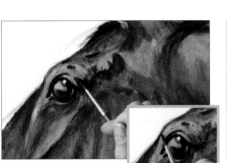

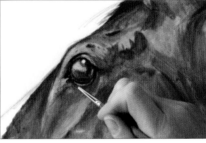

49 To make the orbital area more rounded, paint on strokes of burnt sienna, following the direction of the contours. I then reduced the prominence over the eye by blotting with a wet brush and kitchen paper, then remodelled the prominence with burnt sienna and Winsor violet.

50 Continue drawing with the brush with Payne's gray and neutral tint, shaping the inside corner of the eye and dotting the skin below the eye where it looks porous.

51 Redefine the lips with the same mix, and drag lines upwards to create texture. Darken the nostril with the same mix, then add a rim with burnt sienna.

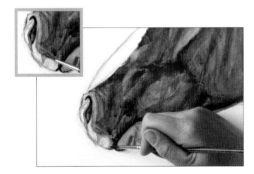

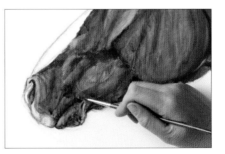

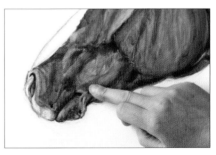

52 Add a dash of burnt sienna to suggest the pink part of the nose, then paint a thin veil of neutral tint around the lips where they turn in.

53 Strengthen the chin and beneath the lip with Payne's gray and neutral tint. Leave a light area for the lip and darken around it with Davy's grey to emphasise it. Lift off paint at the corner of the mouth with a wet brush.

54 Define the area behind the lips with a dry mix of burnt umber and burnt sienna and use your finger to dab it to create texture.

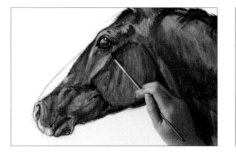

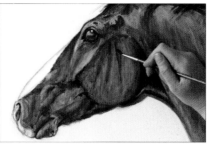

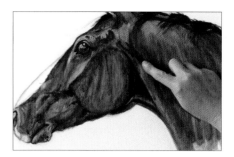

55 Define more contours of the face with the no. 4 brush and burnt sienna and Winsor violet. Drag dilute burnt sienna over the area beneath the facial crest to emphasise it.

56 Darken behind the cheek with burnt sienna, and redefine the tension lines in the cheek.

57 Paint on more contour lines with Van Dyke brown and burnt sienna, and drag them with your finger to soften them.

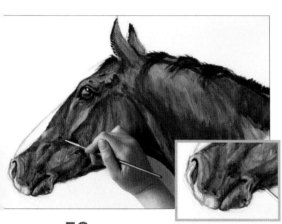

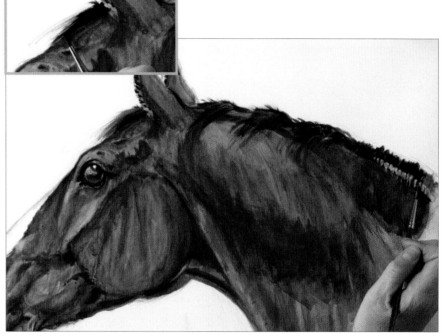

58 Paint a veil of burnt sienna over the areas, below the eye and down below the face marking. Darken the nostril with Payne's gray, making it lighter lower down, and, then darken the groove below the nostril. Add crinkles under the chin with Van Dyke brown.

59 Pick up Payne's gray on a dry brush and flick hairs for the forelock. Then pick up a little white gouache on the tip of the brush and drag this across the forelock to create light streaks. Continue down the mane in the same way. Further down the mane, dab on marks with the white gouache where the mane changes direction. Wet the marks with water.

60 Add a touch of white gouache to the eye highlight and the bony prominence behind the eye. Paint a little over the facial crest and smear it with your finger.

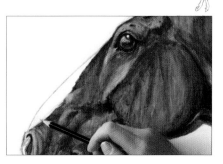

61 Darken the muzzle and lips and the back of the chin with neutral tint, and under the neck with burnt umber.

62 Darken around the eye and the bony prominences, and under the ear, with burnt umber.

63 Paint the white face marking with white gouache and allow it to dry. Use a 2H pencil to add tone over the white gouache. Rub off any unwanted pencil marks.

The finished painting.

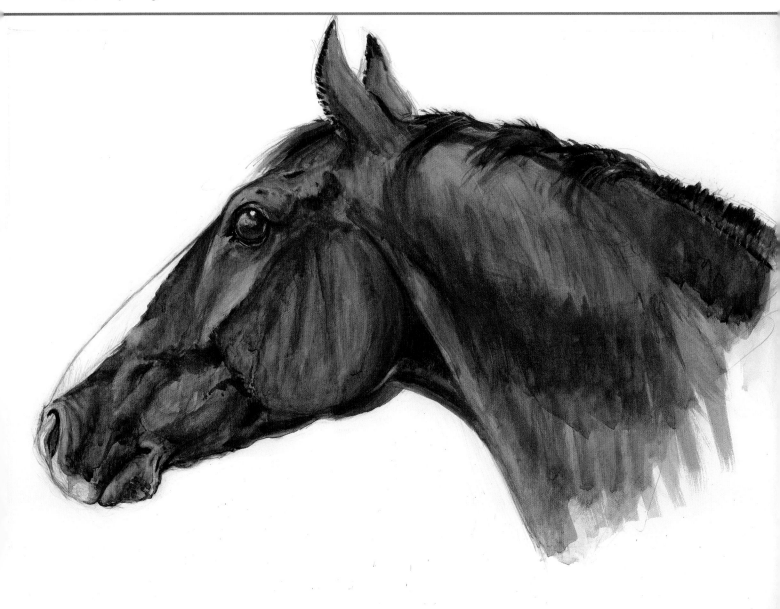

Briar Morgan with Amber Eye
20.3 x 13cm (8 x 5$\frac{1}{8}$in)

This is Briar, a Morgan horse who has an unusual amber pigmentation in his eye. This sketch was worked on while he was very relaxed, standing outside his stable on a warm autumn day. I quickly used a black pen to literally scribble him in, which I enjoyed, especially on his luxuriant mane and forelock. I then painted quite a dilute wash of burnt umber over the whole area except his lower eye, where I added a pale wash of raw sienna. I darkened above this with Payne's gray, leaving a small highlight. I finished by adding more scribbled pen to define bony and muscled areas.

Kinver

40 x 27cm (15¾ x 10⅝in)

Kinver was painted in watercolour using a range of browns and ochres. This horse lived in Kinver Edge, an area of the West Midlands in England.

Three Dressage Horses
59 x 42cm (23¼ x 16½in)

The painting of these three horses was commissioned as a surprise present, therefore I had to work from photographs to keep the secret. I used a heavyweight watercolour paper and watercolour paints. Coincidentally, I ended up riding the two dark horses, Andy and Marquess, years after I had done the painting.

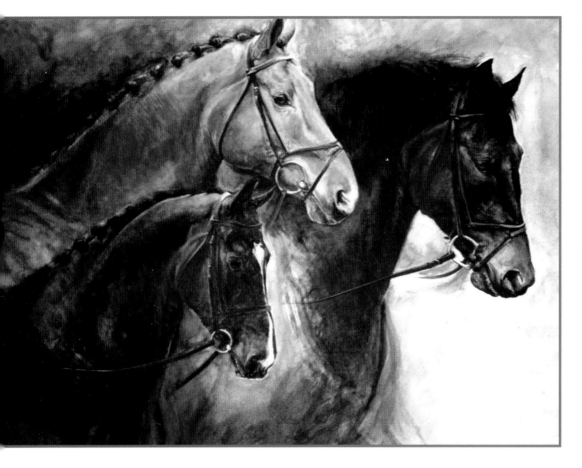

Anglo-Arabs
55 x 48cm
(21¾ x 19in)

These three horses are from the same family. Clockwise from the top is Kizzy the mother, Rupert her son and Lizzy who is half-sister to him. I used to ride Rupert a lot; he was very talented and one of the highlights of my riding career was to be taught by Lucinda Green on a cross-country instructional course where Rupert proved himself to be a star.

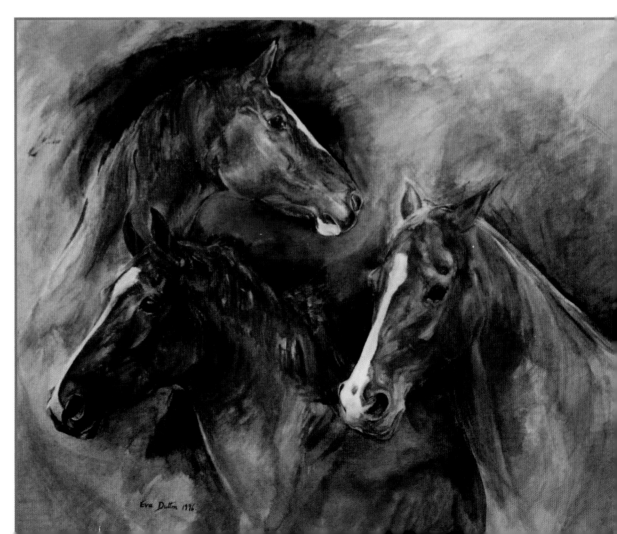

Horse with White Mane

The sketch below inspired this painting. While out driving, I caught a fleeting glimpse of a bay-coloured horse but with a white mane. I had never seen this colouration before, so as soon as I could, I did this sketch from memory, emphasising the mane with white correction fluid. Back in the studio I produced a more developed painting from my sketch and memory. I decided on a green background as I felt it complemented the bay colour well.

You will need

300gsm (140lb) Hot Pressed watercolour paper

2H and F pencils, eraser and sharpener

Watercolours: raw sienna, cadmium orange, cadmium red, burnt sienna, burnt umber, Van Dyke brown, Payne's gray, neutral tint, Davy's grey, Winsor violet, sepia tint, Naples yellow, terra verte, sap green, yellow ochre

White gouache

Brushes: no. 10 round sable/synthetic, no. 4, no 6

Very pale flesh tint soft pastel

Black gel pen

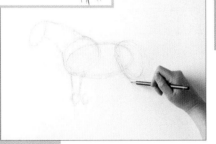

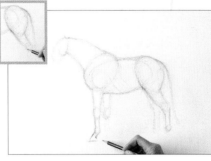

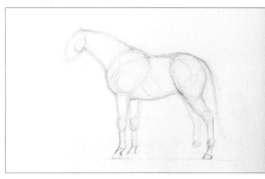

1 Sketch the horse lightly, beginning with the basic shapes such as the head and the curved neck, the high, sloping withers and the rounded hindquarters. Keep your pencil on the paper as this helps the drawing to flow. Place the legs, with circles for the joints. This is a typical conformation stance, showing all four legs. Continue, checking distances, proportions and angles all the time.

2 Put in the tail, which is in a relaxed position. The back leg can be very difficult to get right, so don't worry if you have to redraw. The hock joint should be just a bit higher than the front leg's knee joint. Draw a rounded shape for the cheek and suggest the ribcage. Draw the front hooves; the pastern (the line above the hoof) should be at forty-five degrees to the ground. Put in the ground line.

3 Define the further legs and hooves, and a higher ground line for them.

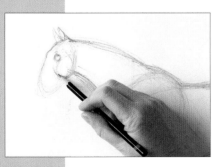

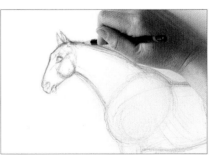

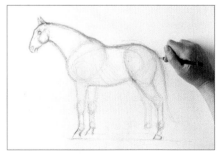

4 Work on the head, turned slightly towards us, and the ears, which are alert. Put in the eye as an anchor point. Redefine the lines.

5 Put in the nostril, the outline of the muzzle and chin and the prominence of the hidden eye. Continue the line of the head through the ears and down the curved neck.

6 Keep the pencil on the paper to draw a continuous, flowing line from the neck, through the body and out into the tail.

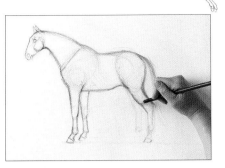

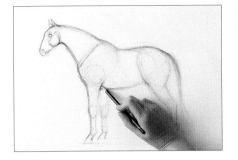

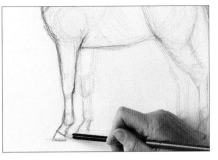

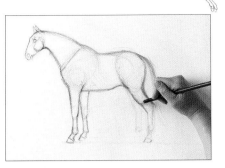

7 Draw the shape under the neck and the jowl area, which in a relaxed horse should be a soft curve. Add contour to the chest and put in the shoulder line at a forty-five degree angle. Make sure the limbs go right up, not stopping at the line of the body.

8 Shape the prominence at the back of the knee, called the pesiform. Add form to the hoof and make a mark to separate it from the leg.

9 Work on the further leg in the same way. Draw the curve of the belly, which goes up where the ribcage ends. Keep the pencil on the paper to draw the back leg, which must be wide enough or it will look too weak.

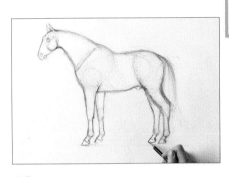

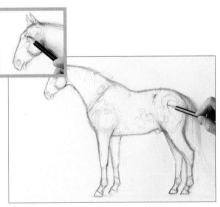

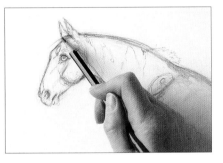

10 The curve at the back of the hock should be just behind the buttock. Draw the further leg and put in the sheath, as this is a gelding. The hoof should point a bit away from us, and we can see the bulbs of the heels at the back of the feet.

11 Mark the borderlines of the white star marking on the forehead, the white stripe on the nose and the three white socks. Roughly mark the mane, then mark the areas of highlight on the glossy coat.

12 Add definition to the eye, mouth and chin. Put in a bit of shading for the pupil and draw the facial crest. Shade the nostril and add a few strokes of the pencil for the forelock.

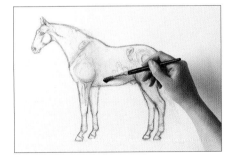

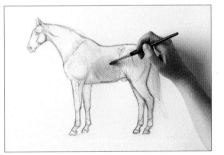

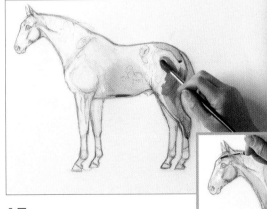

13 Define the muscles at the top of the front leg and in the neck. At this point, refine some of the detail, then clean the paper with your eraser and wash your hands – the drawing stage is finished. Make a dilute wash of raw sienna and use the no. 10 brush to go over all except the white markings.

14 Use the no. 4 brush to paint the hooves with raw sienna. Mix raw sienna and cadmium orange and use the no. 10 brush to paint the ribcage, leaving the highlight areas. While this is wet, drop in a mix of cadmium red and cadmium orange.

15 Block in the darker tone with burnt sienna, leaving the highlights and painting loosely, allowing the paint to flow. Think of the muscles beneath the surface as you paint. Change to the no. 4 brush to paint the face in the same way.

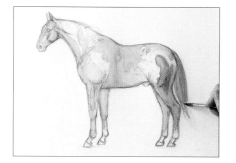

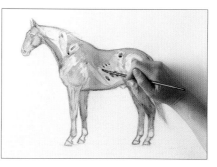

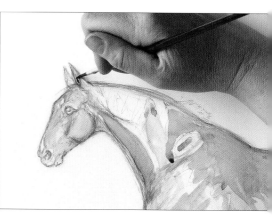

16 Paint the tail with the no. 10 brush and burnt sienna, as reddish tints show even through black tails. As the brush dries, you should get a textured effect.

17 Using the no. 6 brush, add darker tone with fairly dilute burnt umber and burnt sienna, avoiding the highlights. Shape the withers and hindquarters, under the belly and the back leg. Add shade to the further front leg, leaving a highlight for the 'chestnut' – the remnant of an extra toe. Drag lines down for the ribs.

18 Paint the inside of the ear with the no. 4 brush and Van Dyke brown, and mark the tips of the ears.

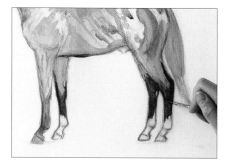

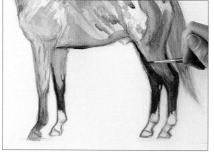

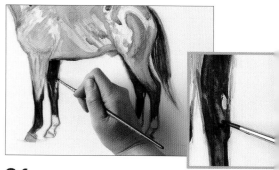

19 Paint the 'black' areas of the legs with Payne's gray with a hint of neutral tint. Paint the near foreleg lightly from the knee with a 'v' shape, and include the hoof. Paint both further legs, going round the 'chestnuts' and leaving white socks. When painting the final back leg, leave the top part lighter to differentiate between the two back legs.

20 Use Van Dyke brown to block in the top of the further back leg, following the contours of the gaskin (the horse's second thigh, which would be a human shin). Block in the sheath with the same colour.

21 Stroke down Payne's gray and neutral tint for the tail, allowing the red highlights to show. I then darkened the front leg and thickened the further front leg with the same mix. Paint Van Dyke brown on the inside of the further foreleg. Lift out paint to lighten the inside of the knee with a clean, damp brush.

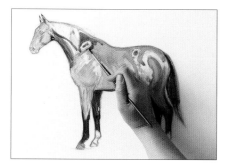

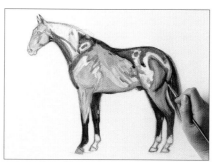

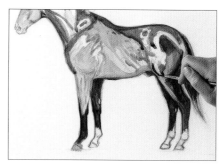

22 Draw in the muscle definition of the neck with Van Dyke brown and burnt sienna, leaving the highlights. Darken the sheath with sepia tint.

23 Draw a line from the shoulder, over the withers and along the back to the tail. Stroke the paint downwards to blend. Define the hindquarters.

24 Darken the back leg, leaving a highlight at the front, then paint round the stifle area at the top of the leg, also leaving a lighter edge at the front.

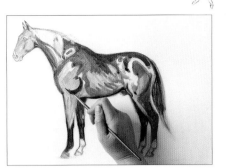

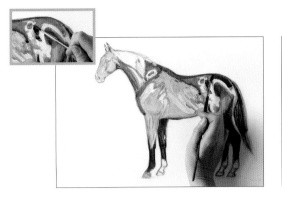

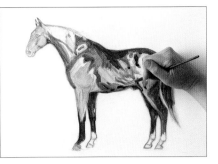

25 Darken the point of the hip with Van Dyke brown. Then with thick burnt sienna, emphasise the top of the hindquarters from front to back with the side of the brush.

26 Run the burnt sienna down on to the main body, going round the highlight and under the curve of the belly. Put in the lower ribcage with sweeping brush strokes.

27 Darken the back of the triceps muscle at the top of the foreleg with burnt sienna and Winsor violet.

28 Paint around the shoulder highlights with burnt sienna and Van Dyke brown. Lift off paint with a clean, damp brush to create the wrinkles in the horse's girth.

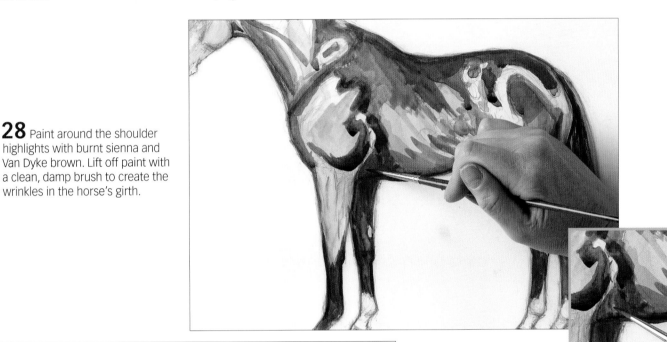

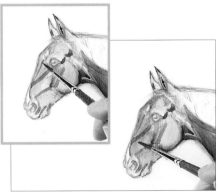

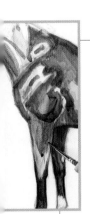

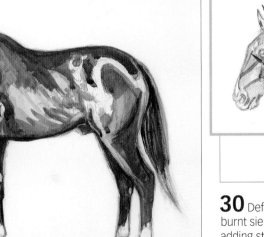

29 Use a strong wash of burnt sienna to redden the neck and shoulder and down the near foreleg, then darken under the neck with burnt sienna and Van Dyke brown.

30 Define the lines of the face with burnt sienna and burnt umber. Continue adding structure lines and then paint a paler wash over the top to blend them in.

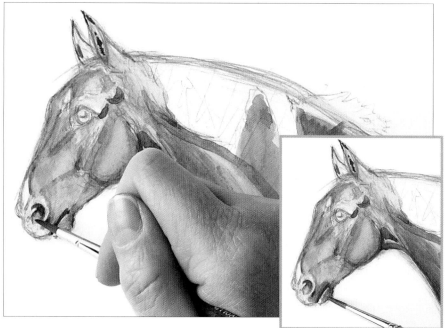

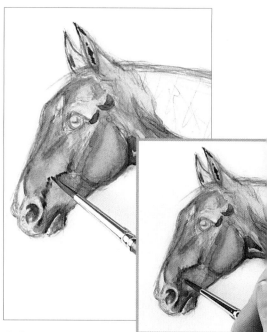

31 Further blend in the cheek and any other lines that look too strong. Mix neutral tint and Payne's gray to paint the mouth, chin and the inside of the nostril. Paint the muzzle area with Davy's grey, blending and dragging it with clean water.

32 Use fairly dry Van Dyke brown to paint from the edge of the nostril up to the facial crest. Go over the line with Davy's grey on a dry brush. Blend with clean water.

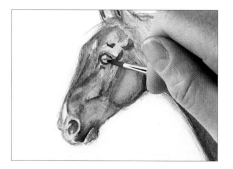

33 Suggest the nasal bones and define the area around the eye socket with Van Dyke brown. Define the eyelids, following the pencil lines.

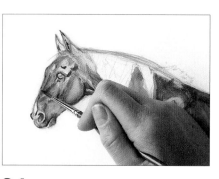

34 Block in the lower half of the eye with a touch of raw sienna, leaving the highlight. Leave to dry. Use almost dry burnt sienna to redefine the face marking above the nostril. Draw in the outer edge of the far nostril and emphasise the profile.

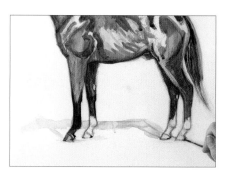

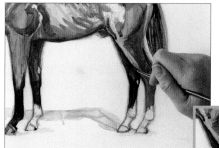

35 Use dilute Payne's gray to paint the shadow. Mix Payne's gray and neutral tint to darken the front leg, under the fetlock and the front of the hoof. Make dark marks at the bottom of the other hooves.

36 Use the same dark mix to paint into the black on the further back leg, drawing lines for tendons and ligaments down from the hock, going round the chestnut and leaving a lighter area on the inside of the hock. Paint a dark groove in the nearer back leg for the achilles tendon.

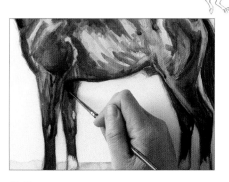

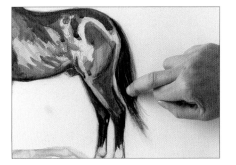

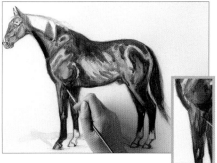

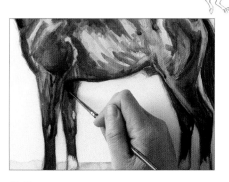

37 Paint the main body of the tail with sepia tint and burnt sienna, then darken it with Payne's gray at the top. Streak lightly with the brush then, while it is damp, scratch out texture with your fingernail.

38 The highlights look too stark, so go over them with the no. 6 brush and burnt sienna with a little raw sienna. Mix Van Dyke brown and a little Winsor violet and burnt sienna and wash over the whole horse except the highlights, using different strengths in different areas. Redefine the muscles of the foreleg. Lift out some colour with a clean, damp brush.

39 Mix Van Dyke brown and a touch of Winsor violet and dot it on to the wet paint to further define the muscles. Darken the leg beneath the girth with the same mix.

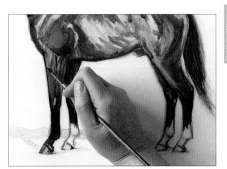

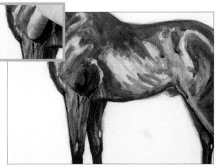

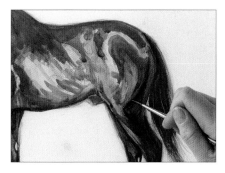

40 Darken the black part of the leg with Payne's gray and neutral tint.

41 Press your thumb in Van Dyke brown and burnt sienna and print this on to the horse's shoulder to define the edge.

42 Dot Winsor violet and Van Dyke brown on to define the muscle in the hindquarters, then blend in with water.

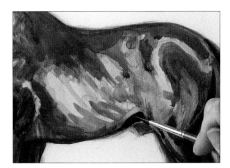

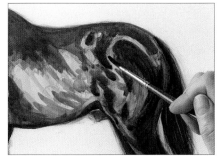

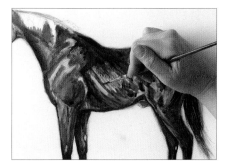

43 Paint a dark line of Van Dyke brown, Winsor violet and burnt sienna to show the difference between the stifle joint and the undercarriage.

44 Darken the hindquarters with the same mix, following their contours with the brush. Paint a dilute wash of burnt sienna over the highlights.

45 Mix burnt sienna with Winsor violet for the rich, glossy tones of the coat. Follow the barrel shape of the ribs using the side of the brush and paint the slope of the withers, leaving some underpainting showing through.

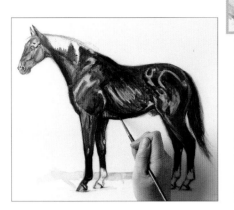

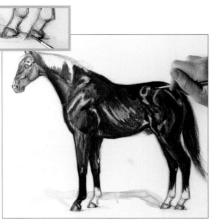

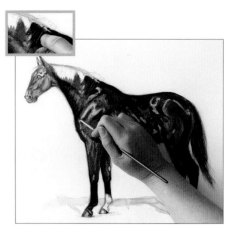

46 Continue, combining wet and dry strokes. Paint under the belly with Winsor violet and Van Dyke brown.

47 Paint Naples yellow on the light hooves, leaving a stripe in the middle. Redefine the line of the back with burnt sienna and Winsor violet. Blend the colour downwards.

48 Continue with this mix up beneath the mane, then scratch out lines with your fingernail to show the folded skin where the horse is looking slightly towards us. Use a dry brush to create texture to define the shoulder.

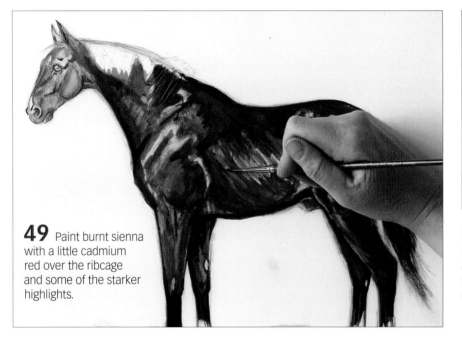

49 Paint burnt sienna with a little cadmium red over the ribcage and some of the starker highlights.

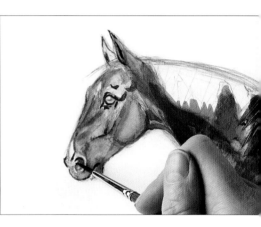

50 Use the tip of a no. 4 brush with sepia tint to define the details of the eye and the inside of the ear. Add a touch at the corner and edge of the upper lip and on the curlicue of the nostril.

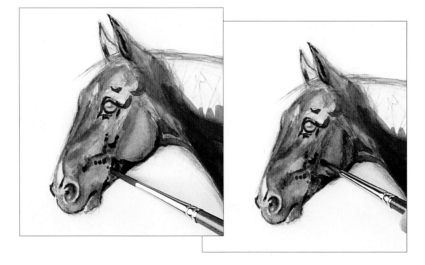

51 Redefine the darker facial features by dotting on strong burnt sienna, then blend this in with a wash of burnt sienna.

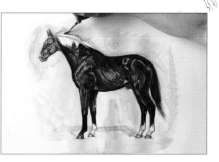

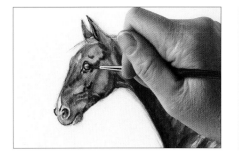

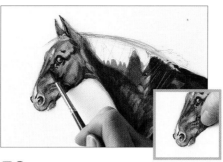

52 Paint a little burnt sienna over the rear part of the eye. When this is dry, touch in the pupil with Payne's gray.

53 Redefine around the eye with Payne's gray, then use burnt sienna to emphasise some of the facial lines. Wet the cheek with burnt sienna, press on your thumb and leave to dry.

54 Paint the background with the no. 10 brush and dilute terra verte and sap green, going over the shadow. Scribble with the brush, changing to the no. 6 nearer the horse and adding a touch of yellow ochre. Use a no. 4 brush for the finest parts, and darken the background over the mane.

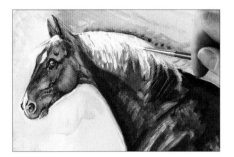

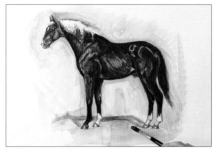

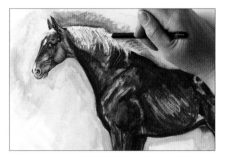

55 Paint the mane with the no. 4 brush and white gouache, then change to the no. 2 brush to paint the face markings. Paint streaks of Payne's gray through the mane, then add more white gouache. You can reshape any of the horse's outline with the green background mixed with white gouache.

56 Darken the shadow with dilute Payne's gray, then make the ground a little darker with terra verte.

57 Darken the background above the mane with terra verte, yellow ochre and Payne's gray. Add Van Dyke brown to the ear tips to define them. Scribble over the mane with an F pencil to add texture. You can add more white gouache afterwards.

58 Use Payne's gray to redefine the details of the muzzle, then add sepia tint to the mix to the eye, the base of the ear and under the forelock. Model the face by adding and lifting out burnt sienna, then paint the upper lip with Davy's grey and blend outwards.

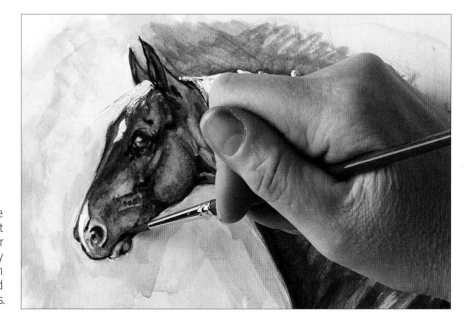

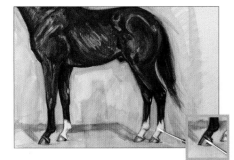

59 Redefine the detail in the legs with Payne's gray and neutral tint, then streak on some white gouache where required. Streak white gouache on to the top of the tail, then add it to the leg markings. Highlight the front hoof with white gouache and Payne's gray.

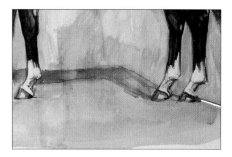

60 Add definition to the socks with pale neutral tint and soften with water. Paint a touch of burnt sienna on the hooves.

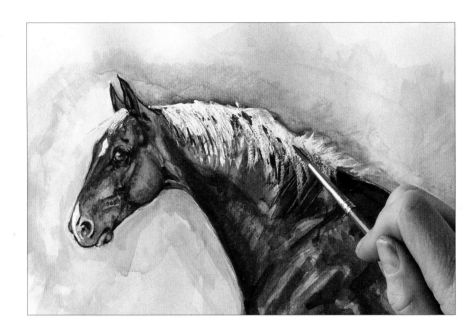

61 Apply more pencil to the mane and then paint a dark mix of Winsor violet and burnt sienna under it.

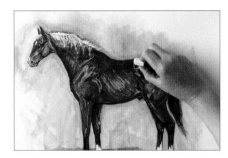

62 Use this same mix only on any areas that seem too light and allow to dry. Use a very pale flesh tint soft pastel to touch over the highlights. You can smudge these with your finger if you like.

63 Finally, use a black gel pen to define any dark areas such as the tail hairs.

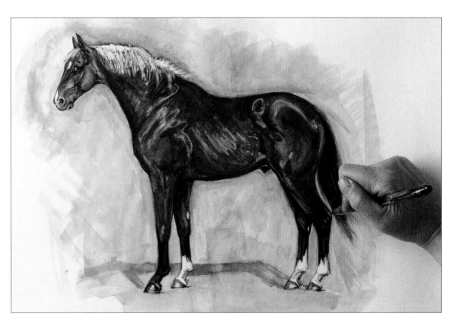

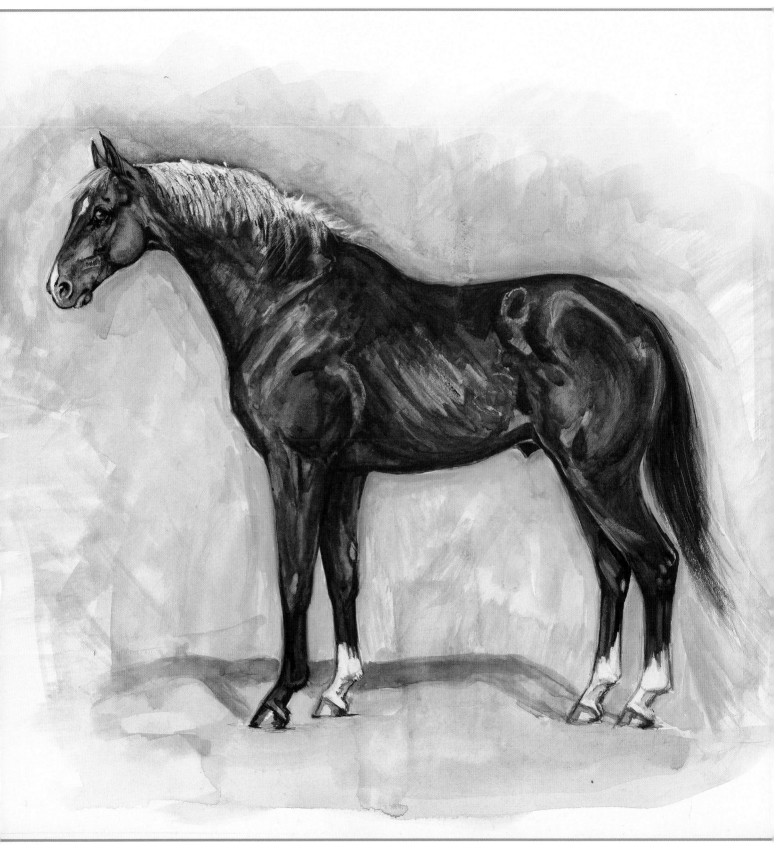

The finished painting.

Grey Mare
35 x 29cm (13¾ x 11½in)

This was done as a study for a later painting. It was done from life with the horse moving freely around a riding ménage. She was slightly concerned by my presence, giving me worried glances. The study was done quite quickly, using pen, pencil and lots of white gouache, sometimes diluted and sometimes used quite thickly, smeared with my fingers to try and convey a sense of movement. A simple background was put in with pen and wash to emphasise the curves of the horse's top line.

Captain – Study of Resting Plough Horse
26.5 x 38cm (10½ x 15in)

This horse is now retired but used to work and do demonstrations at Acton Scott Working Farm which is run as a Victorian farm. One of Captain's jobs was to crush the apples to make cider by circling around driving the mechanism of the cider press. I think he often had apples as a treat.

This study was done on the spot while he was having a brief rest before starting work again – hence he still has some harness on. It was executed using watercolour and white gouache applied with size 10 and 12 brushes. Broad washes and brush strokes were employed to emphasise Captain's size and weight. Notice how he has one ear turned to me as he was mildly interested in what I was doing.

Shivara
42 x 29cm (16½ x 11½in)

This is the sort of pony every horse-mad child dreams of; her mane and tail were like candy floss. With her rich palomino colour, I decided to set her against the lush backdrop of the Shropshire landscape which is where she lived. Her golden coat consisted mainly of burnt sienna, cadmium orange and yellow ochre.

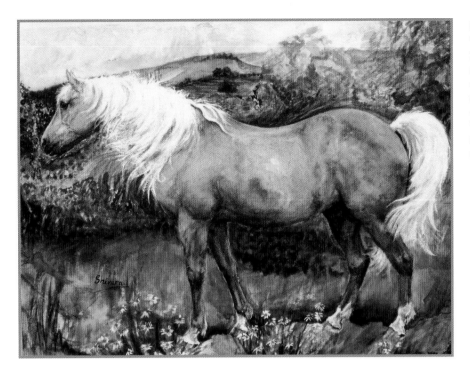

Red Horse
42 x 29cm (16½ x 11½in)

I was drawn to the way this horse's coat colour was complemented by the red brick buildings and their elegant arches. It was completed in watercolour using a range of pinks, reds and browns. The barn's interior is Payne's gray.

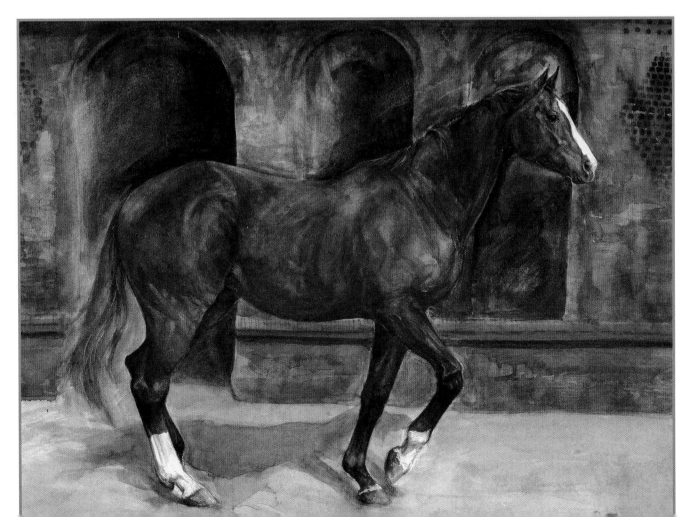

Rearing Horse

This drawing came from a stunt riding course I attended! The horse had been taught to rear on command; he was very sure of what he was doing and so shows a balanced stance and a 'look of eagles' (see page 54). This team of stunt horses are sympathetically trained, their welfare is uppermost in the handler's mind and the horses never react through fear or dominance.

You will need

300gsm (140lb) Hot Pressed watercolour paper
2H, F, 2B, 6B pencils, eraser and sharpener
White gouache
Brushes: no. 6, no. 4 and no. 2 synthetic, no. 10 sable/synthetic
Black gel pen

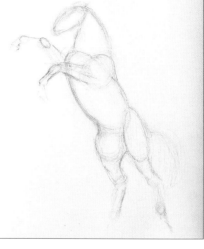

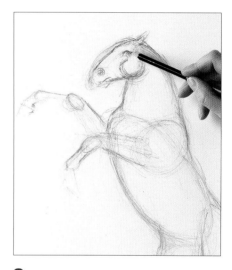

1 Use a piece of paper larger than you think you will need. Start drawing lightly with a 2H pencil, placing simple shapes and keeping the pencil on the paper. Place the back legs first: the strong stance must be right or the horse would fall over and the drawing will look wrong.

2 Start with the highest foreleg, drawing angled ovals for joints. Check the angles from your reference. Draw in the hooves, once again checking for the correct angles.

3 Continue, changing, correcting and adding detail with loose scribbly lines. Place the eye and the cheek, which is pushed back into the neck. Begin to shape the face, drawing the nostril and lips.

4 Define the edges with a more confident pencil line and draw in the midline of the abdomen. Work on the forelegs, observing the soft shapes of the joints in this bent position, and on the unusual shapes of the pelvis and hip joints in this stance. Use tonal pencil marks to follow the line of the neck muscles. Put in the ears. Use the pencil to suggest the movement and drama of this dynamic pose.

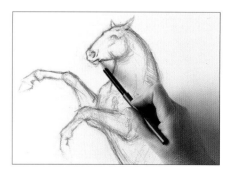

5 Clarify the head. We can just see the protuberance of the hidden eye. Work on the nasal bones, nostril and lips of this solid-looking Andalusian horse.

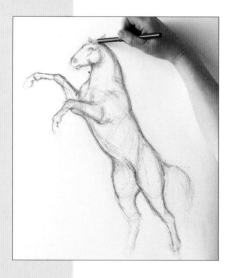

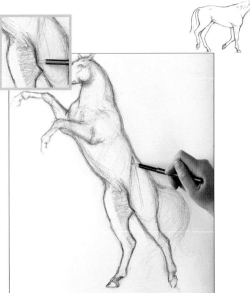

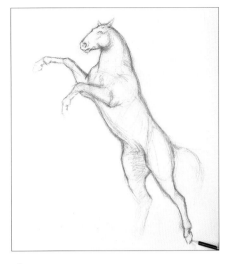

6 Draw lines for the folds of flesh under the neck. Make the downward line of the head, neck and back flow, and shade the inside of the thigh. The left hind leg is raised, so observe and put in the angle of the hoof, with the joint bent and flexed.

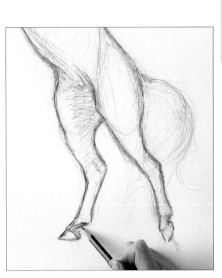

7 Draw the tail with swirling pencil lines, going through the leg. The earthbound leg is carrying a huge amount of weight, so it needs to look braced, locked and tense. Draw the hoof with heavy lines, with the base flat on the ground.

8 The stifle joint (the equivalent of a human knee) should look pronounced, so emphasise it with dark pencil strokes. Drag down lines to show the tightness and tension in the hip.

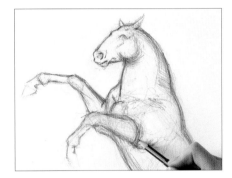

9 Mark the bulging pectoral muscles in the chest and draw curved lines to show the cylindrical shape of the forelimb.

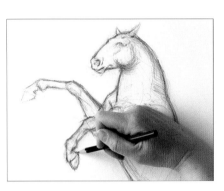

10 Draw the rounded knee shape of the front forelimb, and the fetlock. Shape the hoof.

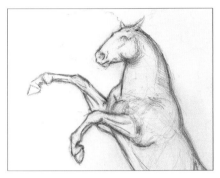

11 Strengthen the shoulder beneath the front forelimb, and the lower edge of the other forelimb visible below. Define the muscles in the forelimbs.

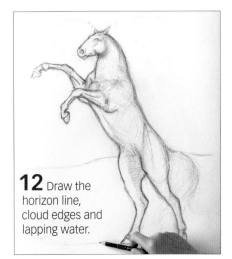

12 Draw the horizon line, cloud edges and lapping water.

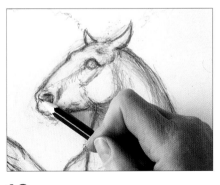

13 Use the softer F pencil to add detail to the eye, ears, protuberance around the eye, facial crest and nostril. Add a line for the far nostril.

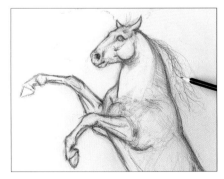

14 Shade the nostril cavity and add a suggestion of the mane.

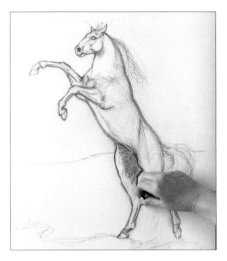

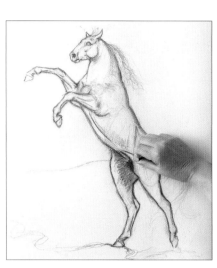

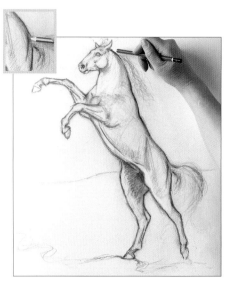

15 Squint at your reference material to get the tones. The darkest part is the shading inside the thigh, so scribble it in with the 2B pencil, adding some cross hatching. It can be darker than the final version. Lift out tone with an eraser for the cord-like tendons and ligaments in the leg.

16 Define the dip the horse is standing on and the hoof. Shade under the abdomen and emphasise the midline. Draw the flap of loose skin from the stifle joint, which should be an elongated triangle shape. Use the eraser to rub off some tone.

17 Draw in another muscle line to show that the pelvis is stretched. Strengthen the line of the back, up to behind the ear.

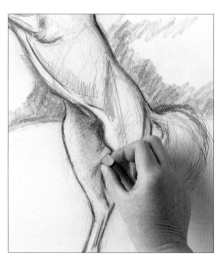

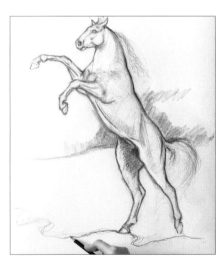

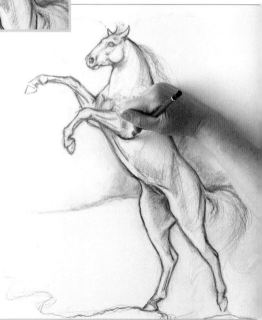

18 Use the 6B pencil on its side to put tone in the background with free shading, creating a tonal relationship between the horse and the sky. To balance this, increase the intensity of the tideline, then fade it into the distance.

19 Use the eraser to lift off tone from the braced leg. Blend, merge and push the graphite.

20 Scribble cloud shapes and use the eraser to smudge and lift out graphite. Continue modelling the horse with the eraser. Use the 2B pencil to shade between the forelimbs, and under the front limb.

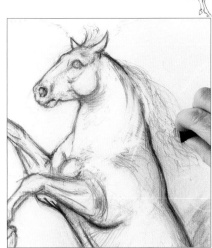

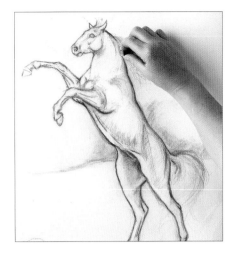

21 Use the eraser to highlight the ribcage, the top of the neck curve and the streaks of mane across the neck.

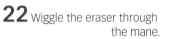

22 Wiggle the eraser through the mane.

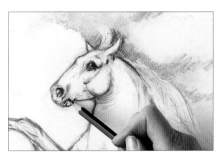

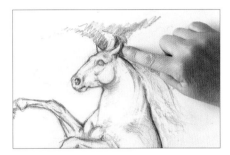

23 Use the 6B pencil on its side to draw the dark parts of the background behind the horse's head, and smudge with your finger.

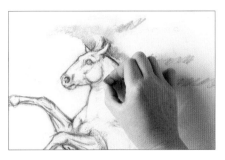

24 Remove graphite from the ears and forehead with the eraser, then use it to create creases on the neck.

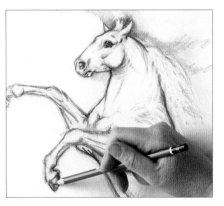

25 Use the 6B pencil to add tone under the chin. Darken the eyelids and pupil. Lightly shade the rest of the eye, leaving a highlight in the top left. Draw expression lines with feathery strokes round the eye, the tense back of the chin and the pursed lips. Add form to the eye socket, facial crest and the lower cheek and jaw.

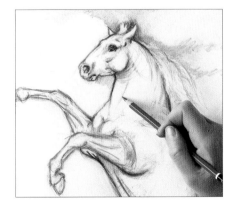

26 Darken the background around the ears, and shorten the forelock. Also shade the background under the chin to highlight the face, and draw the crinkled neck skin with lots of tiny strokes. Draw the muscle down the front of the neck.

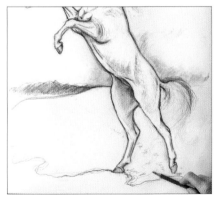

27 Add definition to the hooves, darkening them at the back and front to create a gloss.

28 Draw the hills in the distance, and add marks to suggest that the horse has galloped over the beach, to complete the drawing.

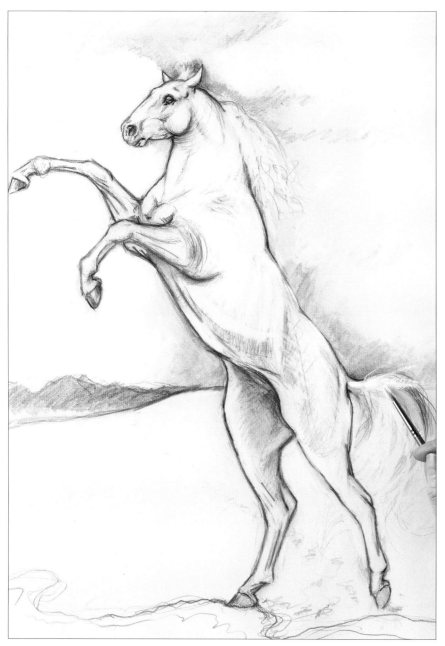

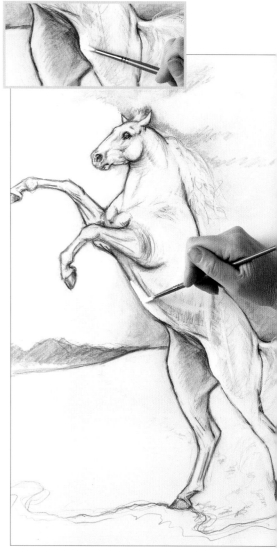

29 Use white gouache on a no. 6 brush to add texture, interest and drama to the picture. Apply it to the shoulder and withers and the ribcage, then drag it fairly dry to create a hazy outline across the hindquarters, and flick it out freely into the tail.

30 Paint the bony part of the stifle joint, then highlight the tension lines in the pelvis and the belly.

31 Paint highlights on the hock joint of the further hind leg and the fetlock of the nearer hind leg, then paint under the lower foreleg, and drag the paint with your finger to soften it.

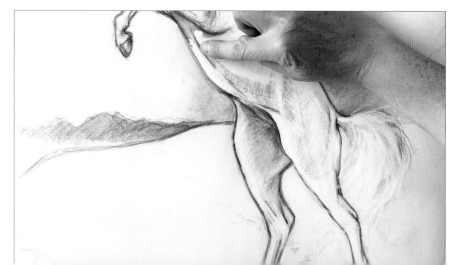

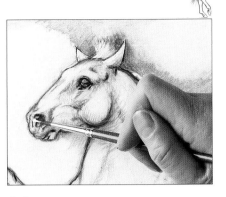

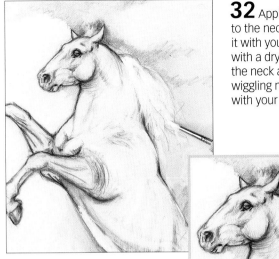

32 Apply paint in the same way to the neck and shoulder and drag it with your finger. Paint the mane with a dry brush, dragging it across the neck and outwards with a wiggling motion. Scratch out lines with your fingernail.

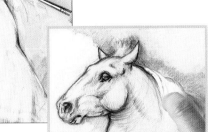

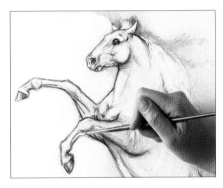

33 Use the no. 4 brush to add highlights to the ears and forelock, and drag paint down over any outlines that are too dark. Add dots and flecks to the rim of the nostrils.

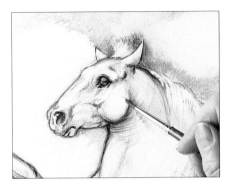

34 Add a glimmer at the corner of the lips and drag a highlight along the facial crest then over the prominence of the eye and the cheek.

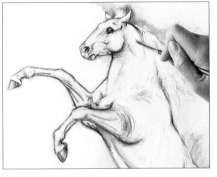

35 Soften the lines of the chest and the higher foreleg, then highlight the bulging neck muscles.

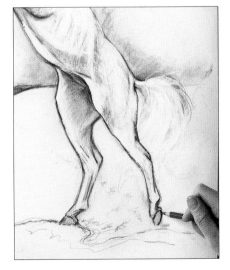

36 Emphasise the cylindrical shape of the nearer foreleg with curved lines of highlight. Also highlight the tendons at the back of the leg.

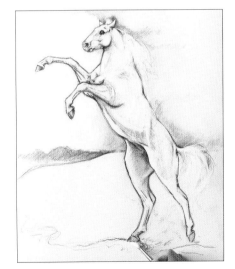

37 Change to a no. 10 brush and use more dilute white gouache to highlight the surf. Flick thicker gouache up into the hoof area to suggest spray.

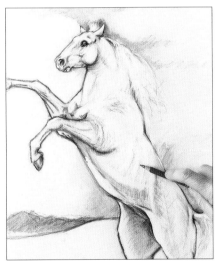

38 When the paint is dry, use the 6B pencil like charcoal to place light strokes of tone between the ribs.

39 Strengthen areas of tone, using pencil over gouache to add texture. Add tone round the hocks and down the legs, and darken the hooves.

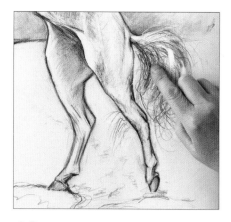

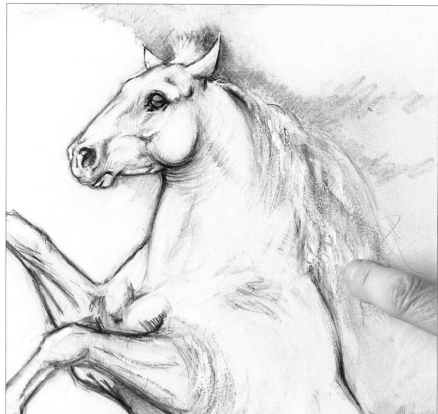

40 Draw lines in the tail with free, easy strokes, and add shade to the left hind leg. Smudge the graphite over the white gouache in the tail with your finger. Pick up gouache on your finger and smear it on.

41 Draw more lines in the mane, and then smear on white gouache in the same way. Scratch out marks with your fingernail.

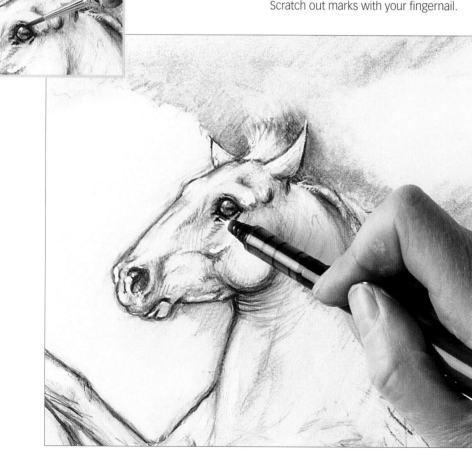

42 Use a no. 2 brush to paint the highlight in the eye, then use a black gel pen to define the eye.

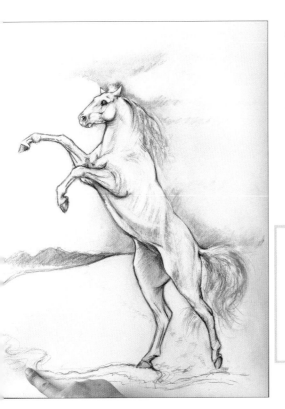

43 Use the 6B pencil to add further definition where needed. Strengthen the ear, the protuberance of the far eye, and the shading under the cheek, neck and chest. Define the muscles in the legs and add shade under the mane and on the hooves. Shade the surf, and smudge with your finger.

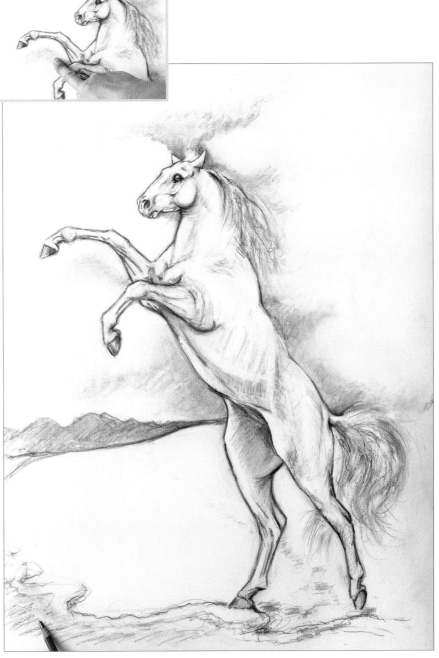

44 Darken the sky in places and smudge and erase as necessary. Add a bit of cloud below the top foreleg and smudge it. Add shade to the water behind the surf.

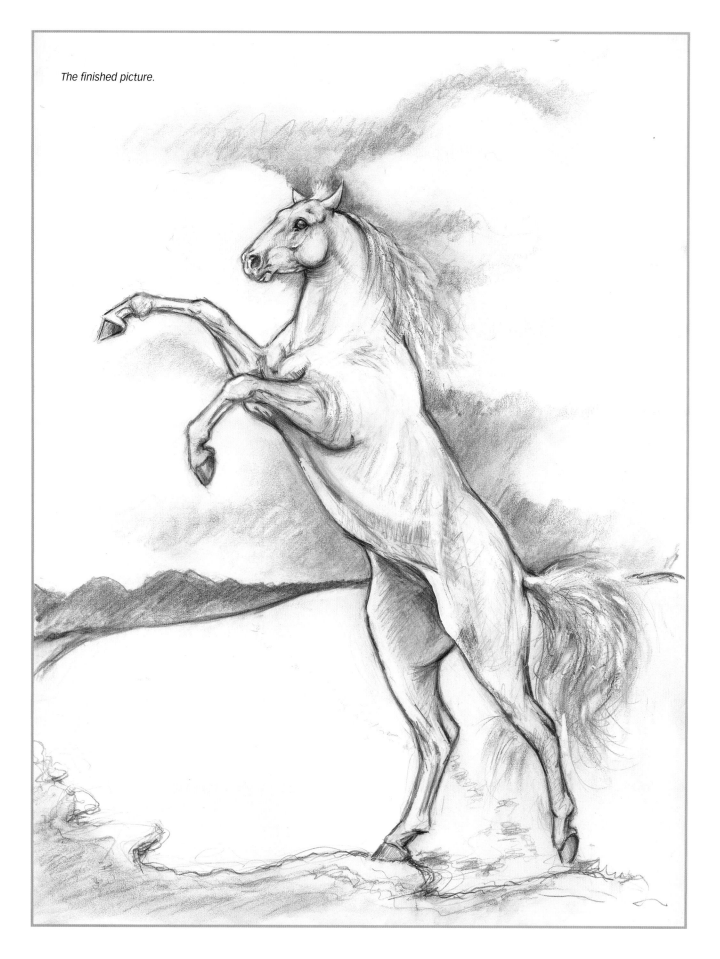

The finished picture.

Titania's Dream

45 x 60cm (15¾ x 23⅝in)

This painting was inspired by the same horse as the demonstration. I placed him next to a mysterious tree that has a story behind it. Embedded in the hollow interior of the trunk is a horseshoe, and no one seems to know why. To me it was as if this horse was a spirit creature that had escaped from the clutches of the tree but left a shoe behind! The painting is quite large so I used a mix of acrylic paint in browns, blues and white as well as sepia inks, which I allowed to drip and dribble down the painting. I used a heavyweight paper and large brushes designed for use with acrylics. Lots of scribbling with a black pen was done over the dry paint.

Mare and Foal on Seashore

The flinging up of the mare's head attracted me to this subject, as well as the foal's eagerness to stick by her side. I decided on a sea view to suggest movement that would complement the flying manes and tails of the mare and foal. The subject matter and setting in this demonstration requires you to be as loose and free as possible with your pencil marks and brush strokes, to really convey a sense of movement and life.

You will need

300gsm (140lb) Hot Pressed watercolour paper

F pencil, eraser and sharpener

Watercolours: Van Dyke brown, Naples yellow, burnt sienna, yellow ochre, terra verte, Davy's grey, raw sienna, cerulean blue, burnt umber, French ultramarine, neutral tint, Payne's gray, Winsor violet, sepia tint

White gouache

Brushes: no. 2, 4, 6 and 10 round synthetic

Kitchen paper

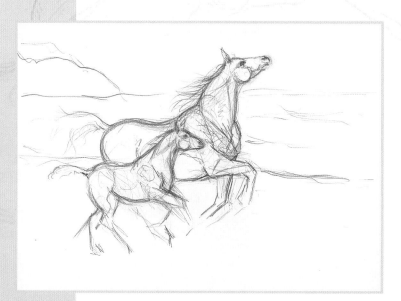

The preliminary sketch.

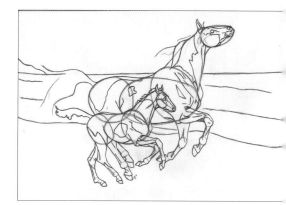

The tracing I used to transfer the image on to watercolour paper. I have simplified the image into basic shapes.

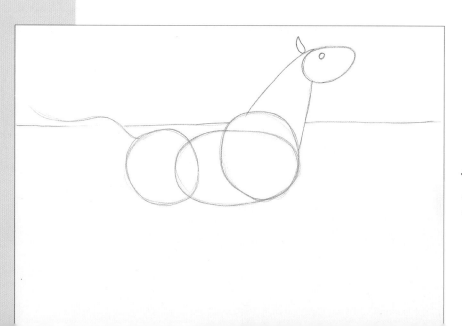

1 Begin with a simple shape drawing of the mare using the F pencil. Draw a horizon line to place her in the picture space.

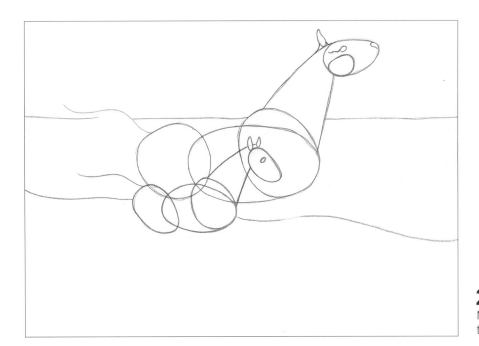

2 Place the foal alongside the mare. Note the difference in size. Also add the shoreline.

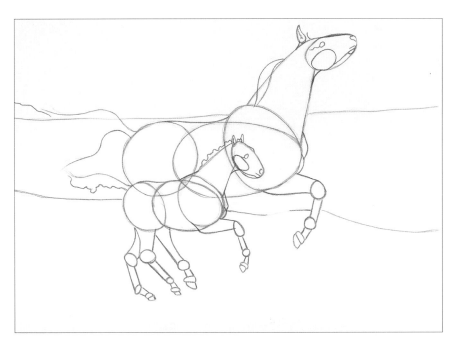

3 Draw in some of the legs, emphasising the action of their movement, to create dynamism in the picture. Add a few face details as well as the horses' tails. Draw the simple headland to the left.

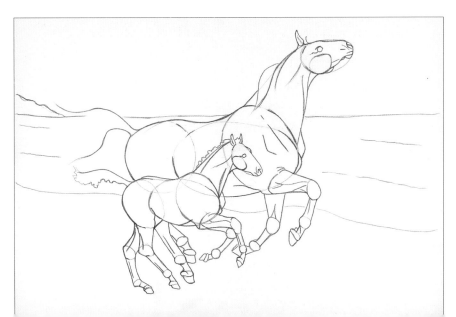

4 Draw in the remaining legs and add further detail. Begin to erase unwanted structural lines so you begin to see more outlines of the two horses acting as a unit. Add some suggestions of waves in the sea.

5 This is the final drawing stage. Show where the markings are to be placed. Try to be fluid with your pencil, scribbling in a touch of tone to give volume. Erase any remaining unwanted structural lines. Add some scribbly suggestions of hoofprints in the sand, as well as clouds and tide marks to place the mare and foal in their surroundings.

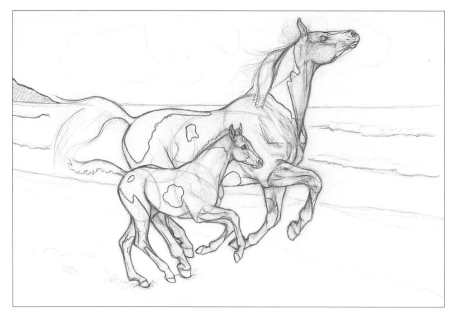

6 Begin the painting stage, using the no. 6 round brush with pale, dilute colours and wash techniques to block in areas. Paint the mare with Van Dyke brown, then change to the no. 4 round to paint the hooves in Naples yellow. The brown parts of the foal should be painted with the no. 6 brush and burnt sienna, and the hooves with the no. 4 round in Naples yellow. Paint the foal's tail with the no. 6 round and burnt sienna, with a slightly darker band along the top. Wash the sand with the no. 10 brush and Naples yellow with a little yellow ochre. Mix very dilute terra verte with Davy's grey and yellow ochre and paint the sea with the no. 10 brush. Make it slightly darker below the headland but leave a white strip to suggest a faraway beach. Paint the headland with a mix of raw sienna and cerulean blue, allowing them to mingle on the paper. Lightly add some patches of French ultramarine at the top of the sky with the no. 6 round, leaving spaces for clouds. Do the same with cerulean blue lower down.

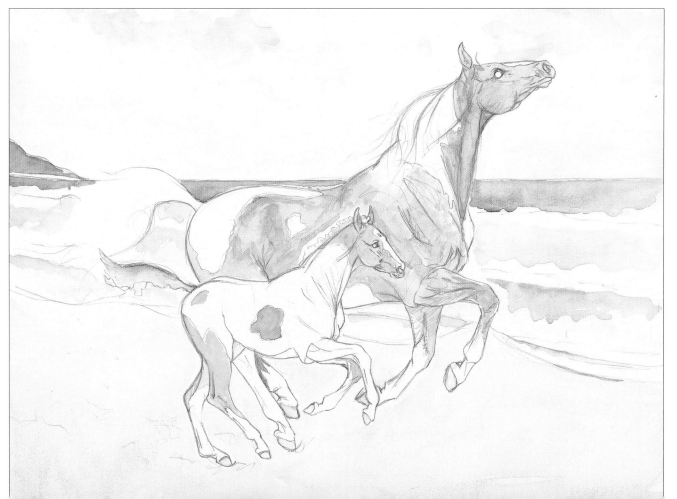

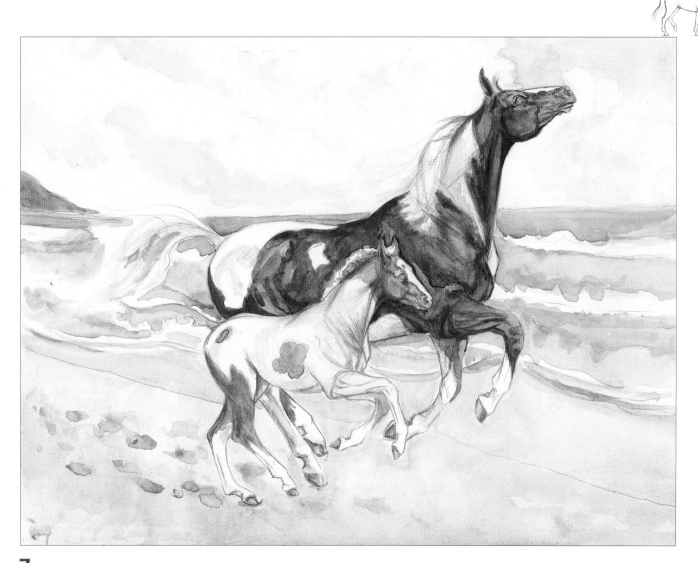

7 When the painting has had time to dry, layer the same colours as before over the horses, using the no. 6 brush for the horses and the no. 4 for their hooves. Allow edges to develop and dry, as you do not want everything to be too smooth and flat. Add some burnt umber to darken the mare's patches of colour. Redefine areas using a pencil and by drawing with a fine brush, especially on the shoulders and the base of the horses' necks. Think about the skull structure and define the shapes by drawing and painting the contours, hollows and lumpy areas.

Use Davy's grey with the no. 4 brush to add hints of shadow on the horses and their hooves. A touch of burnt sienna will help to distinguish the hooves from the sand. Still using the no. 4 brush, paint the mare's tail with burnt sienna and Van Dyke brown, in wet strokes, allowing the colours to bleed. Follow the flow of the tail with your brush strokes.

Define the shoreline with a broad and very pale wash of raw sienna, applied with the no. 4 brush, allowing a hard edge to form as it dries. Blob watery cerulean blue to create hoof marks, and add burnt sienna at the edges.

Darken the sky, defining clouds with the no. 4 brush by leaving white paper showing and allowing edges to form in the blue areas. Intensify the area of French ultramarine around the mare's face so that the white face marking shows up well. Darken the headland, using the same colours as before. Use the no. 2 round to add a pale sweep of burnt sienna below it to suggest a beach. Using the no. 4 brush, darken the sea below the headland using neutral tint and terra verte. Below the waves, use some French ultramarine and Payne's gray. Use brush strokes of raw sienna and burnt sienna to show the edges of the wavelets where they roll on to the beach.

Finally use the no. 2 brush to paint the foal's eyes with very pale cerulean blue and the mare's with burnt umber.

8 At the final stage of painting, intensify the colour on the mare using the no. 4 brush and Winsor violet mixed with burnt umber. Try to leave some areas untouched by these darker tones to suggest light flickering across the coat on the body, limbs and head. Think about following the lie of the hair. Dab with slightly damp kitchen paper to create highlights on the mare's shoulder and right foreleg. This will give extra lift and movement. Follow the same procedure for the foal, highlighting his coloured hind leg that is raised. Use white gouache on the white areas of both horses, but add a little tone with Davy's grey watercolour. Remember that there will never be pure white as you will get light reflecting off the sand and sky. Under the foal's belly, echo slightly the sand colour of raw sienna and burnt sienna. Be very subtle, just using veils of colour.

Use an almost dry no. 4 brush to add the mare's mane and tail with white gouache and Van Dyke brown. Do the same with white gouache over dried burnt sienna on the foal's mane and tail. Scratch out lines with your fingernail to help create the feel of flowing hair.

Use burnt umber on the no. 4 brush to darken the mare's eyes, outlined with sepia tint to settle the eyeball into the socket. Highlight the eye with a tiny speck of white gouache. Darken the inside of the ear with Van Dyke brown.

The foal has a wall eye (see page 67) so mix cerulean blue with white gouache to paint it with the no. 4 brush. Add a white pinprick with white gouache on the dark pupil to give more life. Darken the inside of the ear with Winsor violet.

Finish the sky with the no. 6 brush by scumbling with a very dilute mix of Davy's grey and Winsor violet on a dry brush. Use tiny touches of yellow ochre and burnt sienna in the sky under the mare's chin and above her tail.

Reflect this in the sea under these areas, still using the no. 6 brush. Dot some neutral tint and terra verte under the waves. Darken under the headland with Payne's gray and terra verte. Pencil in some contours of craggy rocks on the headland. Deepen the colour of the sand with washes of raw sienna applied with the no. 4 brush. Under the horses, use the no. 4 brush to flick raw sienna, burnt sienna and cerulean blue to create kicked sand. Define the hooves a little more against the background using pencil. Tighten up the tide line with some burnt sienna and white gouache to make wavelets rolling in. Paint a little terra verte in the sea under the mare's tummy, to create contrast and a sense of space.

Use fine strokes of the pencil to add final definition to the horses's legs, then add seagulls with quick pencil strokes.

The finished painting. You have created your own seahorses!

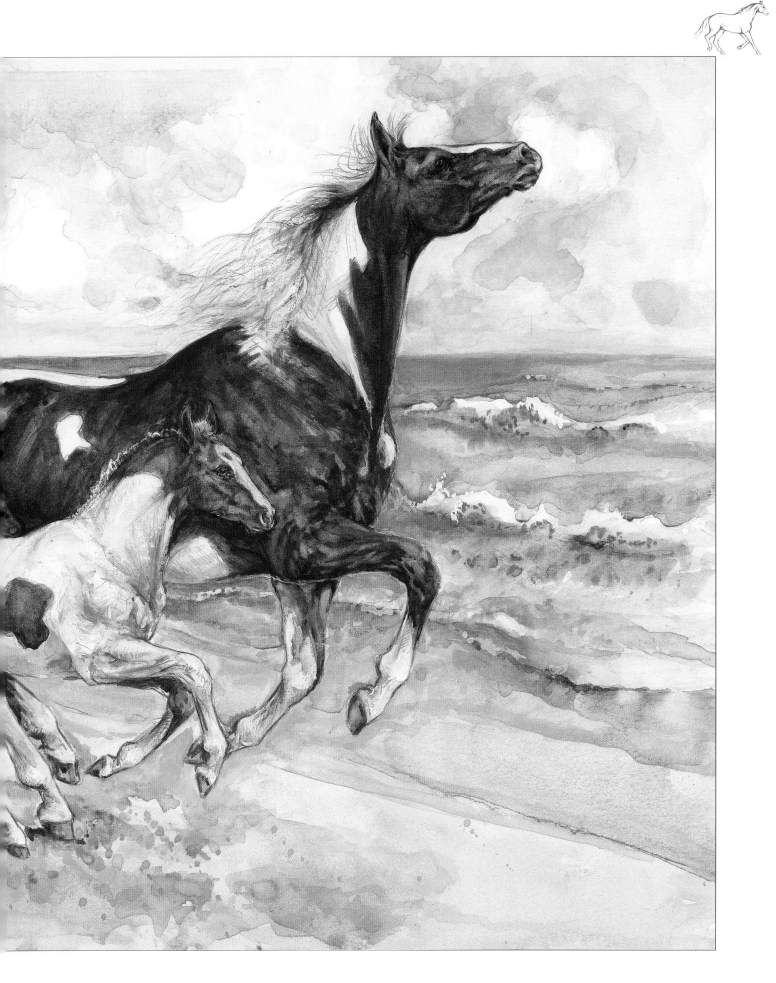

Wave Horses
59 x 42cm (23¼ x 16½in)

The owners of the local riding stables take their horses to the beach when they can, and as you can see, the horses enjoy this as much as the riders. The painting was done back at the studio using sketches and from memory. I used watercolour for the painting, depicting the water splashes with white gouache.

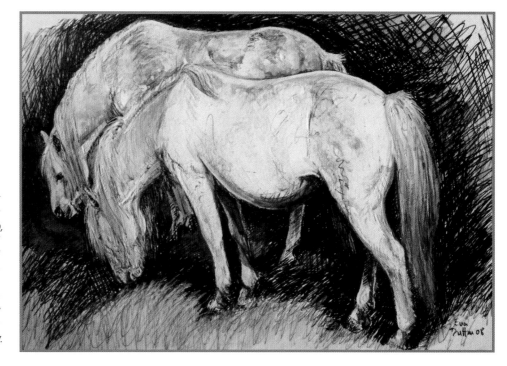

Grazing Greys
30 x 20cm (11¾ x 7⅞in)

This is a sketchy painting done initially on the spot and completed in the studio, showing how the original sketch can also be the final painting. I used lots of white gouache and black pen; you can see the scribble marks where I was trying to work quickly before these two Welsh mares wandered away.

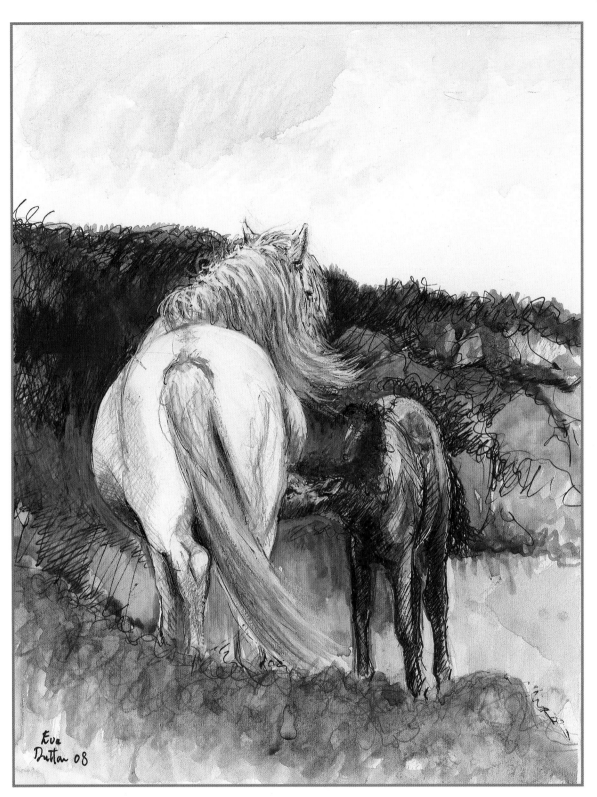

Mare and Suckling Foal
15 x 19½cm (57/8 x 7¾in)

This watercolour and pen painting is a companion to the one on pages 126 and 127. It was done in Shropshire on the Long Mynd where Welsh mountain ponies are turned out on the hillside. Here the foals are born amongst the heather. I often go to the Mynd to find these semi-feral herds of ponies to draw and paint. The mares are very protective of their offspring so you must be very respectful, maintaining a good distance and not interfering, to avoid causing undue stress.

Herd of Hill Ponies

When I sketched this scene, I was struck by the mare watching over her foal and the pony on sentry duty gazing out to sea. In the painting, I changed the position of the grazing pony to lead more into the composition. I took the liberty of adding the sea in this demonstration as in reality it is on inland Welsh hills. The sketch was done on site with pastel crayons which enabled me to get information down quickly, as well as the colours. A more detailed study of the foal lying down can be seen on page 37.

You will need

300gsm (140lb) Not watercolour paper

F pencil, eraser and sharpener

Watercolours: yellow ochre, sepia tint, Payne's gray, burnt umber, raw sienna, Davy's grey, Winsor violet, raw umber, cerulean blue, cadmium yellow, terra verte, indigo, Potter's pink, cobalt blue, sap green, burnt sienna, neutral tint, Van Dyke brown, Naples yellow, cadmium orange

White gouache

Brushes: no. 2, 4, 6 and 10 round synthetic

Kitchen paper

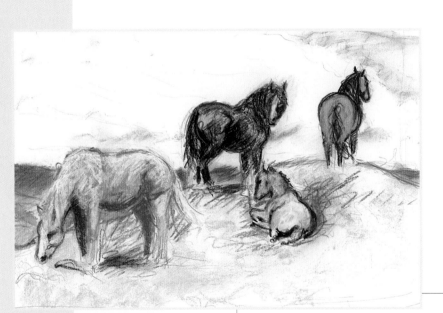

The sketch that inspired this painting.

The tracing I used to transfer the image on to watercolour paper. I have simplified the image into basic shapes and reversed the way the grazing pony is facing.

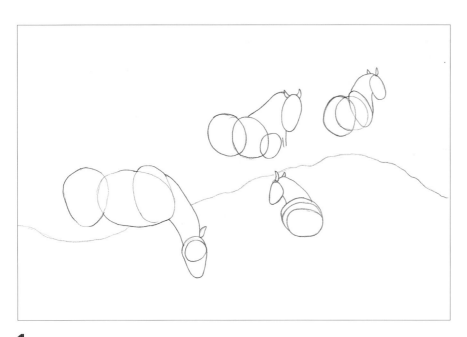

1 Use simple shapes to position the ponies and sketch lightly with an F pencil so that you can erase or paint over unwanted structure lines later. Be aware of differences in scale and size, especially the foal and the nearby grazing pony and the furthest away sentry pony. Use an uneven line to show the hilly contour and to help place the ponies in their setting.

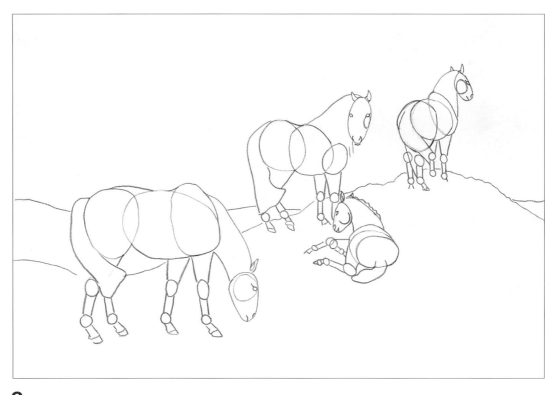

2 Lightly sketch in the limbs and tails and a few other anchor points. Add the far distant lines of the hills and sea.

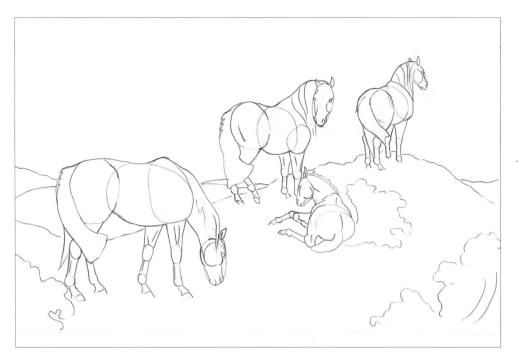

3 Carry on adding detail such as the facial contours and the lie of the manes. Put in more background detail such as gorse bushes and middle distance hill contours. Remember these are still guidelines, so draw lightly and do not worry about mistakes – they may become 'happy accidents'.

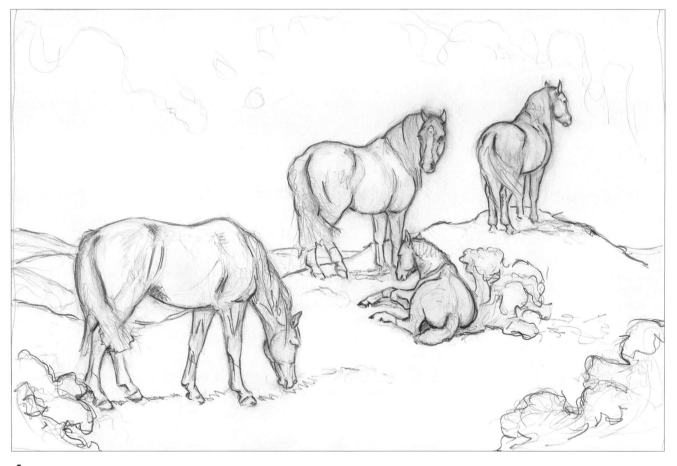

4 Add a fluid pencil line over your shape guides. Erase unnecessary marks. Use some light, scribbly shading to introduce shadow and clouds, and to add volume to the ponies' bodies. Put swing and direction into the manes and tails to suggest a breeze blowing them.

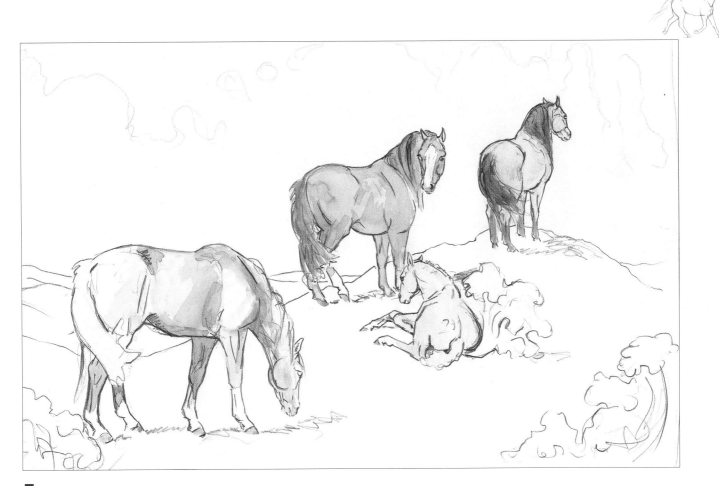

5 Begin painting using the no. 4 round brush with very dilute watercolour washes. Be careful to stay within the pencil lines of the ponies' shapes. Paint the sentry pony with yellow ochre, then mix sepia tint with a tiny bit of Payne's gray to paint the mane, tail and the legs from the knee and hock down. Paint the dam of the foal with burnt umber and her mane and tail with sepia and Payne's gray. Be careful to leave her leg and face markings white. Use raw sienna for the foal, leaving his socks white. Paint the grazing pony with the no. 6 round brush and Payne's gray, using slightly different dilutions of the paint for different areas of tone. Block in the hooves with the no. 2 brush and Davy's grey.

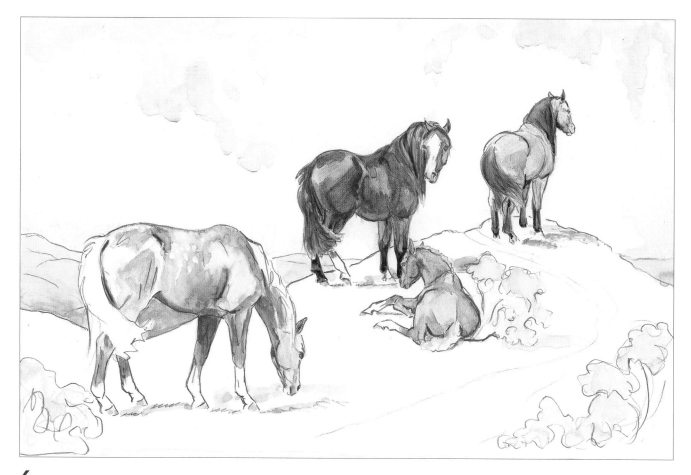

6 Using the no. 4 brush, carry on layering the colours to intensify and model the ponies' shapes, creating volume. The sentry pony is dun, so mix yellow ochre with a little Winsor violet to create contours and definition to the hindquarters, tummy and lower face. Use brush strokes of sepia tint and Winsor violet from the root to the tip of the mane and tail. Make the crest and root of the tail slightly lighter than the tips.

Still using the no. 4 brush, build up burnt umber on the dam's bay body, strengthen her mane and tail and introduce dark tones to her lower legs with sepia and Payne's gray. Use brush strokes to suggest flow and movement, especially on the middle of the neck where her mane hair overlaps. Slightly darken her nostrils and eyes with Davy's grey, then use the no. 2 brush to add a touch of sepia in the eyes only. Strengthen the foal with raw umber on the no. 4 brush, leaving the mane and tail paler.

The grazing pony should be dapple grey, so use the no. 4 brush to add Davy's grey and Payne's gray in layers with dabs of white gouache to suggest the dapples. Add some water on the tip of a brush to cause mingling of paint along the pony's back.

Using the no. 10 brush, paint a wash of pale cerulean blue for the sky. Blot the paint using kitchen paper to lighten areas. Block in the gorse with dilute yellow ochre and a touch of cadmium yellow.

Add a pencil line to suggest a track leading from the foreground to the dun sentry pony. Using the no. 4 brush, add a hint of shadow with terra verte, and in the far distance add some depth with indigo and potter's pink.

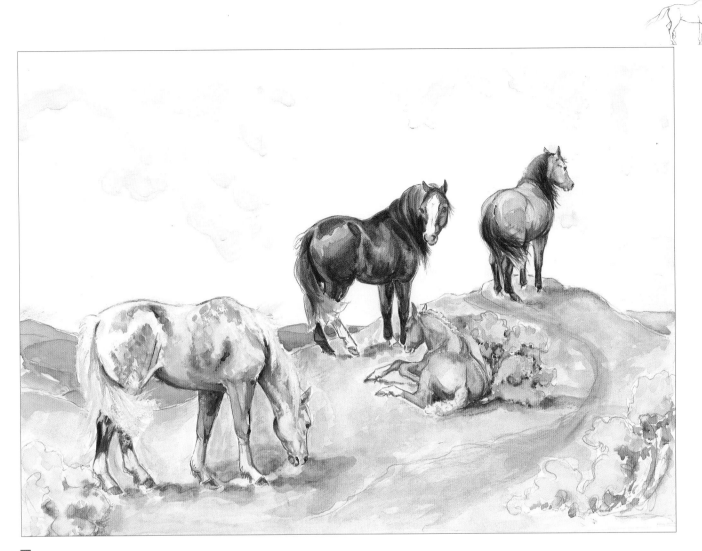

7 Use the no. 4 brush to add a touch of dilute Winsor violet to the body and legs of the dun sentry pony. When this is dry, overlap it with dilute yellow ochre. You can redefine and strengthen areas with a pencil. Darken the mane and tail with brush strokes of burnt umber, flicking the brush at the end to show movement. Darken the legs with sepia tint on the no. 2 brush.

Still using the no. 2 brush, paint burnt umber on the bay dam to darken her legs and hindquarters. Leave a light streak near the tail root to look like light reflected on her glossy coat. Keep building up the mane and tail with sepia tint, but leave the tail tips paler.

With the same brush, add raw umber to the bottom of the foal where it is lying on the ground, and near the gorse bush. Model the lower jaw and the face with some Davy's grey.

Using the no. 4 brush, paint white gouache on the mane and tail of the dapple grazing horse, and while it is still wet, add streaks of raw umber. Define the hooves with the no. 2 brush and Payne's gray on the toe areas. Build up the shadows on the body and under the neck and jaw using Davy's grey and Payne's gray. Add a touch of sepia to the eyes of all the ponies.

Using the no. 10 brush, add a touch of cobalt blue to the higher part of the sky. Wash the foreground with the no. 6 brush and terra verte and add touches of sap green on the hilly contour line. Add deeper shadows with a stronger mix of terra verte. Build the gorse bushes with the no. 4 brush and dabs and washes of cadmium yellow. Shade them with sap green and burnt sienna. Define the track with the no. 6 brush and terra verte overlain with Potter's pink.

Paint neutral tint in the far distance, overlain in the middle distance with terra verte, leaving lighter gaps to fill with dilute sap green.

8 To finish the dun sentry pony, use the tip of the no. 2 brush to define the face, almost drawing with Winsor violet and sepia tint. Be very delicate around the eye and nostril, using tiny amounts of paint on the brush tip. Add touches of white to the pastern areas. Stroke yellow ochre on to the body, imagining that you are following the lie of the coat hair. Stroke Van Dyke brown on to the mane and tail using the brush tip and a flicking action.

Darken the bay dam's face to suggest more shape, defining the eyes with a tiny highlight. Leave her right eye a little lighter than her left eye so that it shows up more against her mane. Use white gouache on her white leg markings, and when this is dry, lightly use a pencil to show shadow.

Add dots of pencil, yellow ochre, Naples yellow and white gouache to the foal's mane and tail to give a fluffy texture. Use the no. 4 brush and yellow ochre and raw sienna to show the neck muscles as the foal turns his head. Leave the eyelashes white so that the eye shows up against the dark of the bay's leg. Use a pencil to define the shape of the foal's legs and then the no. 2 brush to add some Naples yellow and Davy's grey to the hooves.

To finish the dapple grey, streak the mane and tail with raw sienna, letting it get quite dark (I have never seen a clean mane and tail on a Welsh hill pony!) Add white gouache to the leg markings, then when this is dry, use pencil to emphasise the legs against the grass. Add more dots of Davy's grey and Payne's gray with the no. 4 brush until you feel you have achieved the dappled effect. Add dots of white gouache if you have darkened them too much. Add a tiny white highlight in the eye with the no. 2 brush.

Finish the sky using the no. 10 brush and dilute cobalt blue, blotting the sky near the horizon line to keep it paler in the far distance. Add a bit of Davy's grey on the left horizon, suggesting a storm approaching. Add a touch of cobalt blue to the sea on the far right with the no. 6 brush. Strengthen the foreground and shadows with the no. 4 brush, adding some burnt umber to your greens and to the pink track. Border this track with very dilute Payne's gray on the left, to create depth. Use dots of cadmium yellow and cadmium orange on the gorse to create texture. Darken the green and burnt sienna areas to create the effect of clumps of foliage. Finish by using terra verte and sap green to make some fields bordered by hedges and trees in the middle distance, next to the dapple grey. Leave pink under his belly to make him stand out more.

The painting is now finished. Don't look at it for a few days, then come back and have another look. You may spot areas that can be improved upon, or you may be happy to leave it be.

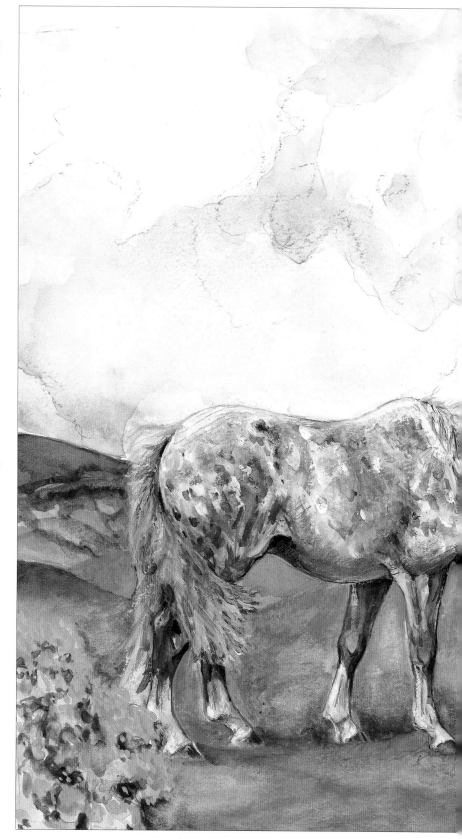

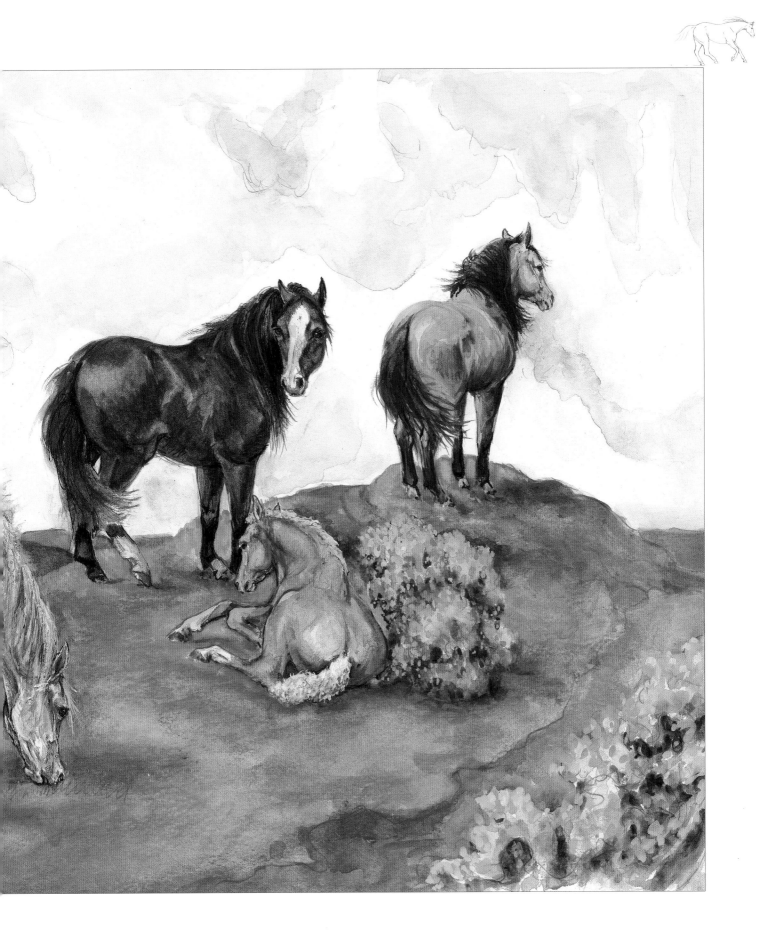

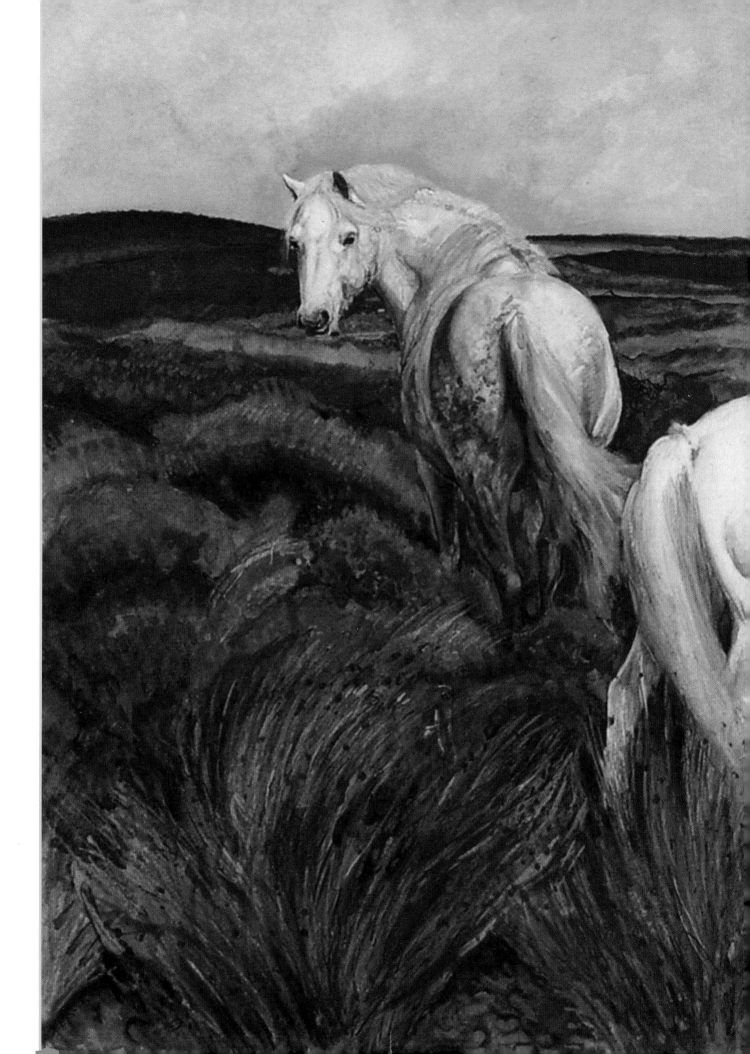

Long Mynd Mares
29.5 x 25.5cm (11⅝ x 10in)

The Long Mynd in Shropshire is home to several small herds of Welsh mountain ponies. They are most often grey or dappled in colouring, and they contrast beautifully with the purple heather. Both these mares had foals, which are just out of view. I did several studies and sketches on site, some of which appear elsewhere in this book. The final work was done in the studio (where it was a lot warmer). I used watercolour, pen and white gouache. I also used quite a lot of scratching out with my fingernails to create the reedy grasses in the foreground while the paint was still wet.

Index